We went, we returned. We went; we returned. We went: we returned. Now place softens to become the lining of the mouth. Our older relatives are none now and are holding us into our mouths. Now a rh. Now we climb into our dress, sew ourselves into air. There tongues. Maybe they are the older relatives. Now we run our fingers over their fingers and are startled into humility. Now sequins we've burst too from the terrestrial emotional surface. We can't understand cloth, home, anything. Are we here to say we can't sustain this register? We can't yet participate in lost death. We must get into this soft lining. Now we were born complex, messy, wilful, doubled, into tables and postcards and mats. Our faces now model themselves outwards towards themselves. Now we have or own a shelf. We need it or don't. All the memory stretches out in a continual thin plane. Our faces keep reading it. Now place signs dirty water, plants, coins, unraveled stuff. All the memory is false, therefore necessary. We're speaking for the air in the shape-filled cities, the air of the black branches, the objects covered in string, the smudged paper against the metal fence, some spatial confusion which replaces love. Now we move gently as the prepositions. What is communicate? Deep in our bodies it is better than this. Deep in our doubt a terrestrial clicking. Now we wish to be in one place yet move like blackbirds.

Occasional Work
and
Seven Walks
from the
Office for Soft Architecture

by Lisa Robertson

Coach House Books

Toronto

Third edition
The first edition was published in the U.S. by Clear Cut Press, 2003
The second edition was published in Canada by Coach House, 2006
Coach House Books gratefully acknowledges the support of the Canada Council for the Arts and the Ontario Arts Council. The publisher also appreciates the support of the Government of Ontario through the Ontario Book Fund and the Ontario Book Publishing Tax Credit and the Government of Canada through the Canada Book Fund.

 Canada

Coach House Books would also like to thank Matthew Stadler and Rich Jensen of Clear Cut Press for their support of the reissue of this book, which they so expertly and bravely published in 2003. Robin Mitchell and Tae Won Yu were kind enough to share files.

LIBRARY AND ARCHIVES CANADA CATALOGUING IN PUBLICATION

Robertson, Lisa, 1961-
 Occasional work and seven walks from the Office for Soft Architecture / Lisa Robertson.

Includes index.
ISBN 978-1-55245-232-5
 1. Vancouver (B.C.)--Miscellanea. I. Office for Soft Architecture (Association) II. Title.

PS8585.03217033 2011 C814'.54 C2011-903586-5

Contents

Introduction
by Petra Blaisse

The descriptive and expressive essays so beautifully written by
Lisa Robertson at the end of the twentieth and beginning of the
twenty-first century (only a couple of years ago), collected in the
now republished book *Occasional Work and Seven Walks from the
Office for Soft Architecture* and now in front of you, need less of an
introduction (she herself takes you right into a situation: 'Thus,
the park. The bursts of early evening rain …') than they need
explanation ('This is an inverted Utopia, where *sous la plage, le pavé*.
Nothing and everything took place here, then moved on'), so I
wonder if anything of value can be added by me (a Dutch plan-
ner of 'soft architecture,' if you insist, not always catching but
tasting each of Lisa's chosen, often newly constructed words
like one does a foreign spice or dish, pleasantly surprised to
recognize some of its ingredients) before one starts reading Lisa's
own flowing cutting dreaming slashing warming warning texts
that are the voice of a person who experiences the urban envi-
ronment like the interior of a room or a sensuous stroll through
a landscape (its organization a permanent political and eco-
nomic thermometer), a woman who sees feels thinks links hardly
digested already puts into words that one detail in that particu-
lar context at that moment (and that weather) in a country,
region, city, suburb, neighbourhood, street, park, spot that is
familiar or unfamiliar to her yet to someone else maybe whom
she's with whom she might or might not know who might or

7

might not amuse, intrigue or tickle her in reality, fantasy or memory but in any case her sentences address and describe all senses cells molecules at once and each of those poem prose rhythmic sentences, long or short, knits together words, intentions and meanings lyrically synthetically intellectually or hilariously, connecting historic facts to technical details to day-to-day torments to social attempts to political intention to personal memory and moods to police precision to romantic girlishness to philosophic wisdom, knit knit knot knot nag note fold quote slice revel ramble lift zip snap steel stitch stalk stop! ... continuing what seems her everlasting journey of seeing describing recomposing, wondering where what how why hard soft architecture better worse more beautiful?

Amsterdam, June 2010

The Office for Soft Architecture came into being as I watched the city of Vancouver dissolve in the fluid called money. Buildings disappeared into newness. I tried to recall spaces, and what I remembered was surfaces. Here and there money had tarried. The result seemed emotional. I wanted to document this process. I began to research the history of surfaces. I included my own desires in the research. In this way, I became multiple. I became money.

Soft Architecture:
A Manifesto

Dossier:
> **Photographs by**
> **Andreas Pauly**
> **Curtains by**
> **Petra Blaisse**

Summer 1998. Artspeak Gallery (Vancouver) and Dazibaou Gallery (Montreal) commissioned a text for a catalogue of the work of artists Sharyn Yuen and Josée Bernard. A theory of cloth, memory and gods emerged during afternoons in Sharyn Yuen's studio, the Metropolitan Museum and the Frick Collection. This seemed to pertain to urban geography, especially to the speed and mutability of Vancouver's built environment. The piece was later republished by Nest magazine, which commissioned Andreas Pauly to photograph curtains by Petra Blaisse.

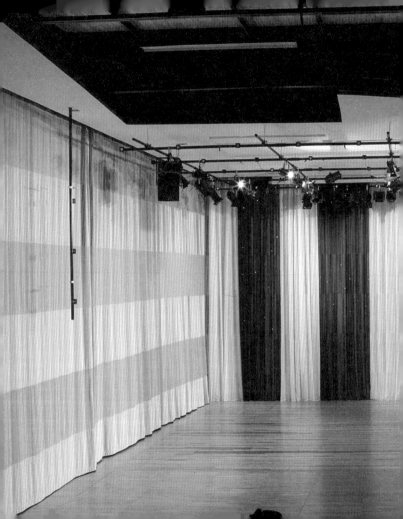

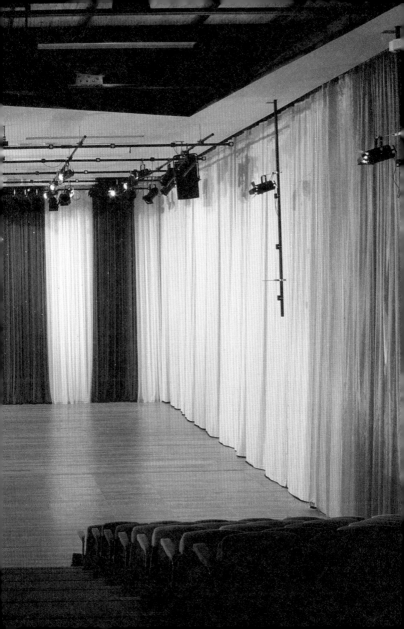

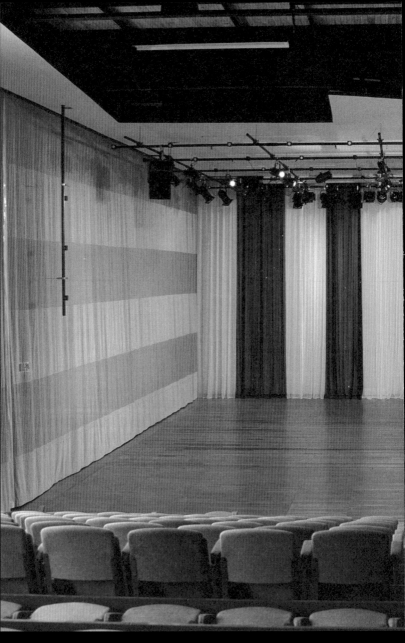

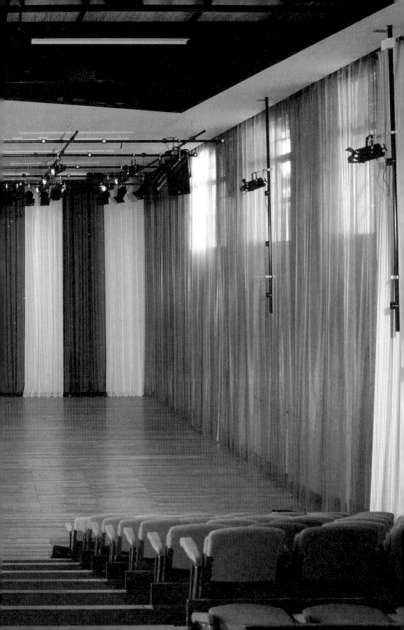

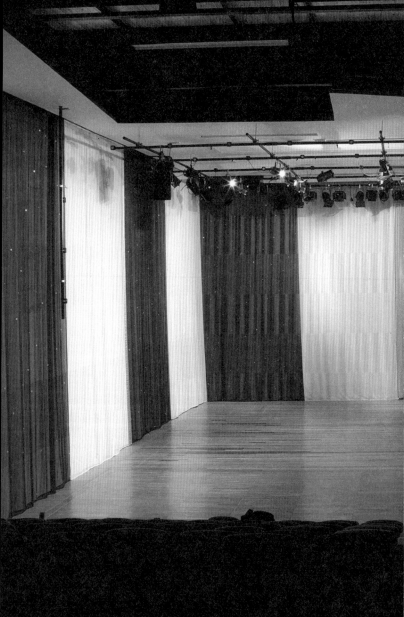

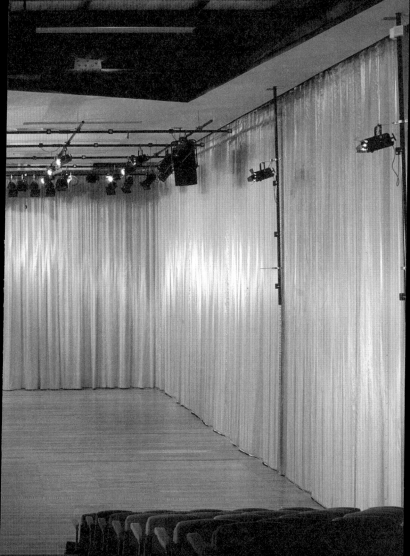

The worn cotton sheets of our little beds had the blurred texture of silk crêpe and when we lay against them in the evening we'd rub, rhythmically, one foot against the soothing folds of fabric, waiting for sleep. That way we slowly wore through the thinning cloth. Our feet would get tangled in the fretted gap.

We walked through the soft arcade. We became an architect.

The knitted cap on the wrinkled skull of the mewling kid is the first boundary. At the other tip the bootie dribbles. There are curious histories of shrouds. That is not all. Memory's architecture is neither palatial nor theatrical but soft.

Of course it's all myth. Beginning at grand rooms ranked in small stone Natufian couples co-mingled in kisses, the perspex galleries of pendant Babylonian dollies, the long halls of Egyptian cats that are sirens or dynasties, we amble towards the disappearance of godliness into cloth. Europe's lusty godlets start bending. Carved cloth connotes the wild swirls of the Christly sexual parts. Sprigged calico greets the renaissance of Venus. Prudery flows animate, clinging, vivid – we think it absorbs virility from naked Antiquity herself. Strolling from Byzantium we observe her teasing retreat. The mischievious and the sexy gods get dressed as patrons and courtesans and popes, crinolined in Fragonard's stiff satins, diminished to tiny petticoated players in painted enamel frolics. Finally invisible they loll in the latent conventions of canvas, or in the draperies and *objets* of the rooms themselves, such as the Frick's crushed mohair swags, the personified tapestry walls, the little petit-point chairs personified, the chamberpot, the silken floor personified.

We arrive at our long century. We note that the holy modernism of the white room is draped and lined in its newness by labile counter-structures of moving silk, fur, leather, onyx, velvet. The modernist inventors of the moot science of psychoanalysis raise its cold visage from the deep upholsteries and ruched cushions of the speaking invalid's couch. A contemporary describes the late Maria Callas's vibrato as 'a worn velvet that has lost the evenness of its texture.' As for us, we wear avant-thrift. We sit in spider-like chairs. But Soft Architecture expires invisibly as the mass rhetorics of structural permanence transmit: Who can say when the astonishing complicities of the woven decay into rote? The bare ruin of Bauhaus and the long autopsy of concepts serve as emblems of Soft Architecture's demise.

Yet our city is persistently soft. We see it like a raw encampment at the edge of the rocks, a camp for a navy vying to return to a place that has disappeared. So the camp is a permanent transience, the buildings or shelters like tents – tents of steel, chipboard, stucco, glass, cement, paper and various claddings – tents rising and falling in the glittering rhythm which is null rhythm, which is the flux of modern careers. At the centre of the tent encampment, the density of the temporary in a tantrum of action; on peripheries over silent grass of playing fields the fizzy mauveness of seed-fringe hovering. Our favourite on-ramp curving sveltely round to the cement bridge, left side overhung with a small-leafed tree that sprays the roof of our car with its particular vibrato shade. Curved velveteen of asphalt as we merge

with the bridge traffic, the inlet, the filmic afternoon. The city is a florescence of surface.

Under the pavement, pavement. Hoaxes, failures, porches, archaeological strata spread out on a continuous thin plane; softness and speed, echoes, spores, tropes, fonts; not identity but incident and the accumulation of air miles; unmarked solitude absorbing time, bloating to become an environment, indexical euphorias, the unravelling of laughter; a brief history of escalators; memory manifest, brindled, loosening; a crumpling of automotive glass; the pornographic, the wrapped; Helvetica's black dust: All doctrine is foreign to us. The problem of the shape of choice is mainly retrospective. That wild nostalgia leans into the sheer volubility of incompetence. This nostalgia musters symbols with no relation to necessity – civic sequins, apertures that record and tend the fickleness of social gifts. Containing only supple space, nostalgia feeds our imagination's strategic ineptitude. Forget the journals, conferences, salons, textbooks and media of dissemination. We say thought's object is not knowledge but living. We do not like it elsewhere.

The truly utopian act is to manifest current conditions and dialects. Practice description. Description is mystical. It is afterlife because it is life's reflection or reverse. Place is accident posing as politics. And vice versa. Therefore it's tragic and big.

We recommenders of present action have learned to say 'perhaps' our bodies produce space; 'perhaps' our words make a bunting canopy; 'perhaps' the hand-struck, palpable wall is an anti-discipline; 'perhaps' by the term 'everyday life' we also mean

the potential. We allude sympathetically to the lyrical tone of clothing and furniture since they clearly reveal to the eye, mind and judgement the real shapes of peopled sentiment. Cravats gushing from collars, we agree with the Soft Architect Lilly Reich that 'clothes may also have metaphysical effects by means of their inherent regularity, their coolness and reserve, their coquettish cheerfulness and liveliness, their playful grace, their sound simplicity and their dignity.' From the vast urbanity of our counter-discipline we applaud the mercurial Miss Reich, who said, 'One of my hearts is in building.'

Soft Architecture will reverse the wrongheaded story of structural deepness. That institution is all doors but no entrances. The work of the SA paradoxically recompiles the metaphysics of surface, performing a horizontal research which greets shreds of fibre, pigment flakes, the bleaching of light, proofs of lint, ink, spore, liquid and pixilation, the strange, frail, leaky cloths and sketchings and gestures which we are. The work of the SA, simultaneously strong and weak, makes new descriptions on the warp of former events. By descriptions, we mean moistly critical dreams, morphological thefts, authentic registers of pleasant customs, accidents posing as intentions. SA makes up face-practices.

What if there is no 'space,' only a permanent, slow-motion mystic takeover, an implausibly careening awning? Nothing is utopian. Everything wants to be. Soft Architects face the reaching middle.

SOURCES

Agrest, Diana, ed. *The Sex of Architecture*. New York: Harry S. Abrams, 1996.

Calvino, Italo. *Invisible Cities*. Trans. William Weaver. San Diego: Harcourt, Inc., 1974.

Koolhaas, Rem. *Delirious New York: A Retroactive Manifesto for Manhattan*. New York: Oxford University Press, 1978.

McQuaid, Matilda, ed. *Lilly Reich: Designer and Architect*. New York: The Museum of Modern Art, 1996.

Rousseau, Jean-Jacques. *Reveries of the Solitary Walker*. Trans. Peter France. London: Penguin, 1979.

Venturi, Robert, and Denise Scott Brown. *Learning from Las Vegas: The Forgotten Symbolism of Architectural Form*. Cambridge, Mass., and London: MIT Press, 1977.

Pure Surface

Dossier:

**Photographs by
Keith Higgins**

*Summer 1998. Mix magazine (Toronto) asked the Office to prepare
a text for a special issue about the suburbs. The accompanying dossier
of Keith Higgins's photographs of the contemporary vernacular
housing style, the Vancouver Special, draws from Higgins's website
vancouverspecial.com.*

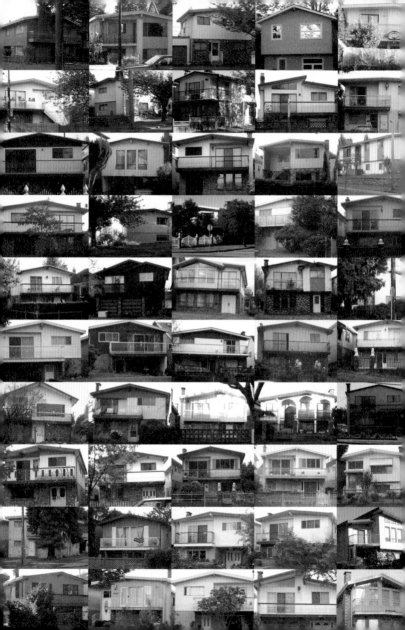

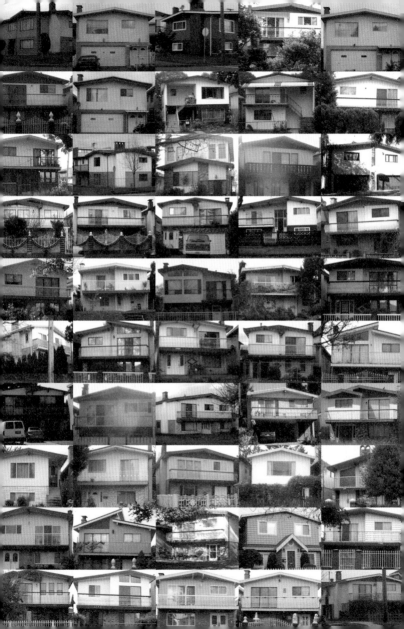

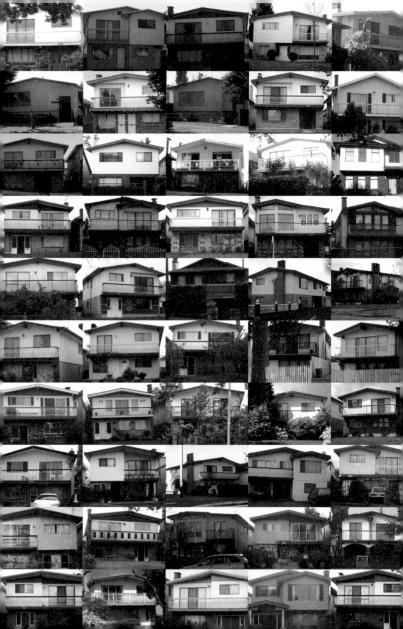

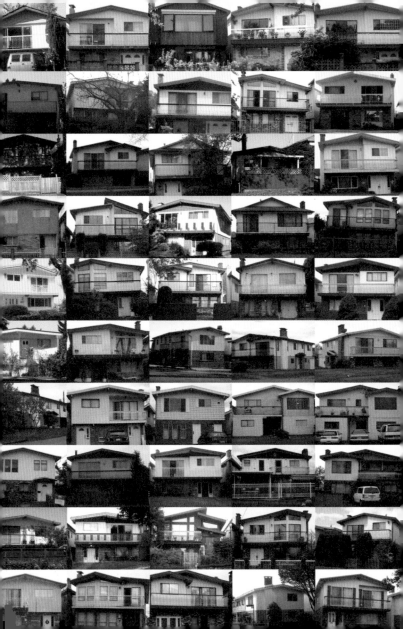

Belief is difficult. It suits us to write in this raw city. Maybe it's the spanner-framed and buttered light slabbed or trickling into soot, soft clicking of louvred Chanel billboards, puce sky swathing the night-time overpass where on every radio of every taxicab Rousseau croons 'we are born innocent' over and over in whining vibrato. The superstores and their parking lots scroll past. Against the distant tile wall of the Advanced Light Rapid Transit facility the city composes itself in the skirts of some teens. All the polished black marble's stripped from the abandoned modernist newspaper building. For a few days it's a gothic ruin, the dark steel structure visible, concrete dangling in gangrenous chunks from the knotted fists of defunct wiring. In the long succession of follies a condo named Portico will soon rise from the reusable site. The daily newspapers have relocated to the suburbs.

The suburb is a received idea, a quoted stupidity, a commonplace cliché, a spatial imposter, a couple of curios, an idle machine, a proof of the great chain of simulation. In Flaubert's *Dictionary of Received Ideas* it falls between stud-farms and suffering, and close to sybarites. 'Suburbs: Terrifying in times of revolution.' Like revolution, the suburb is spurious. But maybe utopia is memory, unbearably simple and symmetrical and practical. Our suburb flaunts the awkward authenticity of an origin. Here is what we remember:

The hour should be evening and the season summer. It is suppertime, the lesson of manners. Fanning waterworks moisten driveways and sidewalks in synchronized shimmers. Ranks

of acid-coloured geraniums border picture windows on both sides of the silent street. The concrete tubs on the concrete patios overflow with well-fertilized petunias. Latent diving boards bisect swimming pools too clean for reflection.

The suburb is a child's Versailles. The long *allées*, soothing symmetries, weedless clipped lawns and floral parterres unfold the security of a formal order that repeats to the vanishing point of the schoolyard. These are memories, so the scale of things is vast, the horizon unattainable, the vegetation sparse, symbolic. The spindly blooming tree at the edge of each lawn has grown, has been joined by a motley speckling of unpruned shrubs. Then, the lawns were mostly empty. Everything was visible. The childish comfort of the explicit, the regular, the habitual was piqued by the vagaries of adult bridge parties and the relation of Simplicity tissue-paper patterns to the mothers' Mary Quant shifts. At dining room tables each afternoon the ideal Quantian toilette ghosted the whirring of Singer sewing machines, puffing of steam irons, the olive broadloom mined with pins, shrill scissoring of cloth, while in backyards kids kissed in lawn chairs under the galvanized antennae towers. We were taught by fathers that if we spun around on the rec room floor until we fell over dizzy, that is how it felt to be drunk.

At noon our bare knees hit the pavement without flinching. Friendship was an exquisitely inflexible choreography of confession and betrayal. Books were weapons.

Everything we learned in the suburb has turned out to be true. In adulthood also we will be watched and corrected by our

neighbours, whose own privacies will remain impenetrable. We will strive for clarity and order. We will want flowers and the evening return of pleasantries. We will commute between our desire and our economy. Our little fort will be discovered. We will leave.

Hence the cruel wit of the suburb. Though a completely revealed site, it yields only negative ontologies. The suburb is memory fattening to russet then paling to flush when it bursts before dropping as whiteness on parked cars. While 'equilibrium' is a lovely suburban word – with its horse-games and moot-courts and love-games and libraries – it seems sad and impossible that this interminably symbolic landscape finally does not refer to anything other than itself. Like one's own childhood, the suburb is both inescapable and inescapably difficult to believe in, and as such, intolerably represents an elegance specific to our economy.

SOURCES

De Certeau, Michel. *The Practice of Everyday Life*. Berkeley: University of California Press, 1984.

De Quincey, Thomas. *Confessions of an English Opium Eater*. Hertfordshire: Wordsworth Classics, 1994.

Flaubert, Gustave. *Bouvard and Pecuchet with the Dictionary of Received Ideas*. Trans. A. J. Krailsheimer. London: Penguin, 1976.

Kant, Immanuel. *Observations on the Feeling of the Beautiful and the Sublime*. Trans. John T. Goldthwait. Berkeley: University of California Press, 1991.

Page, Russell. *The Education of a Gardener*. London: Vintage, 1994.

Smithson, Robert. 'A Tour of the Monuments of Passaic, New Jersey.' In *Some Detached Houses*. Vancouver, B.C.: Contemporary Art Gallery, 1990.

Woolf, Virginia. *The Crowded Dance of Modern Life: Selected Essays*. Ed. Rachel Bowlby. Vol. 2. London: Penguin, 1993.

Site Report:
New Brighton Park

Dossier:

 Photographs by
 Lloyd Center

Fall 1999. Mix magazine invited a contribution for an issue about real estate. The parcel of land now occupied by New Brighton Park in East Vancouver was subject to the first real estate transaction in the city. Historical research concerning the site was conducted at Vancouver City Archives and in the Northwest History Room at Vancouver Public Library.

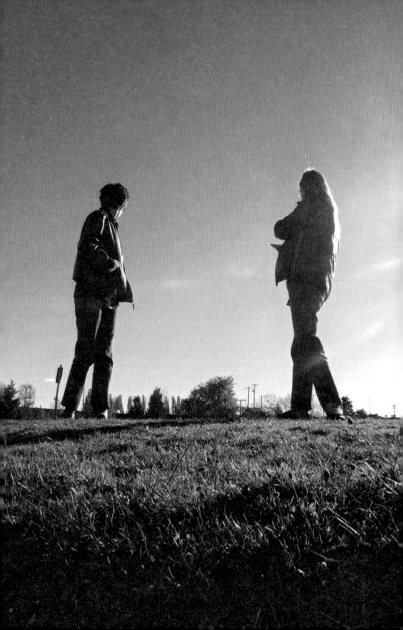

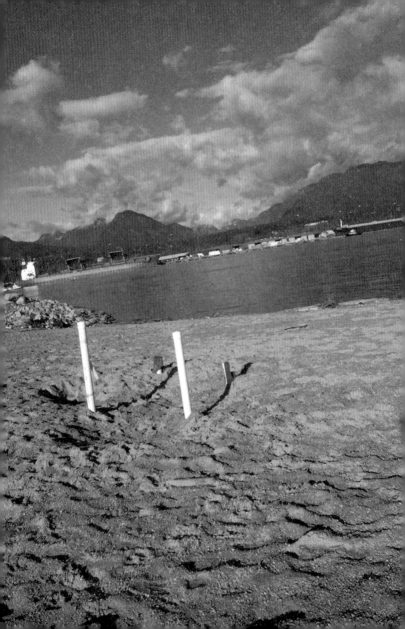

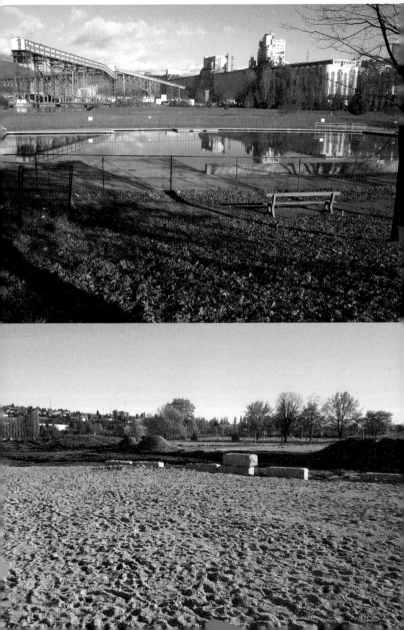

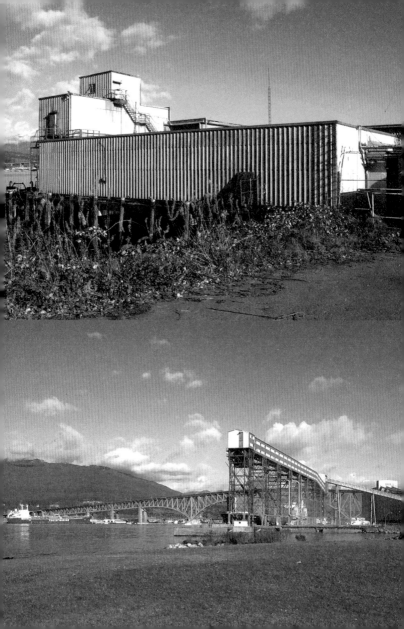

If there is to be a 'new urbanism' it will not be based on the twin
fantasies of order and omnipotence; it will be the staging of uncer-
tainty; it will no longer be concerned with the arrangement of more
or less permanent objects but with the irrigation of territories
with potential …

– Rem Koolhaas

The new urbanism began at this site in 1863. It beautifully lacks architecture. This is an inverted Utopia, where *sous la plage, le pavé*. Nothing and everything took place here, then moved on. No sophistication is necessary. Except for the swimming pool change room and food concession (circa 1970), buildings are absent. The land here is largely fabricated.

At New Brighton Park heavy industry flanks the 'passive and spontaneous' leisure grounds. To the west of the picnic oaks, the new concrete overpass for the Port of Vancouver truck route, the potential site of Lafarge cement plant (now a dustbowl ringed in blackberries), and beyond, the jauntily colourful container yards. To the east of the disused tennis courts, monumental massing of the Alberta Wheat Pool grain elevators, now renamed Cascadia, and beyond these, Second Narrows Bridge. South of the outdoor swimming pool, veiled in chain-link, slow movement of grain cars on the Canadian Pacific Railway tracks. North is Burrard Inlet, the wooden fishing pier, the freighter dock, and across the inlet at North Vancouver the shipyards and barges and sulfur heaps. This blurred conflation of soft and hard uses structures the site.

Near the concession stand a commemorative bronze plaque narrates the park's civic historical status: 'Here Vancouver began. All was forest towering to the skies. British Royal Engineers surveyed it into lots, 1863, and named the area Hastings Townsite … Everything began at Hastings. The first post office, customs, road, bridge, hotel, stable, telegraph, dock, ferry, playing field, museum, CPR Office. It was the most fashionable watering place in British Columbia.' We shall add to this inaugural mythos an additional fact: the site also comprised the first real estate transaction in what was to become our city. From its inception New Brighton has remained emblematic of colonial economies: primary industry, leisure and real estate find here their passive monument.

Lot 26 was purchased at land auction in New Westminster in 1869, $25 down, $25 later, by George Black, Scots butcher. This was the first colonial sale of the Musqueam clam beach called Khanamoot. Black built a hotel, Brighton House, and made cricket grounds and a covered roller-skating rink that doubled as dancehall, founding a playland at the end of the first stagecoach route in the colony. From the then-capital city, New Westminster, to the new wilderness resort, the plank road followed an existing native trail. A contemporary account describes how at Brighton (the colloquial name for the officially designated Hastings) 'beautiful grounds and picturesque walks are being laid out … Even now it is almost daily being visited by pleasure parties.' Brighton, England's colonial doppelgänger, prospered. Then in 1887 the CPR arrived. The terminus was to the west, at Gastown,

and city development shifted westward with the railway. The famous New Brighton Hotel burned in 1905. In 1909 Black's widow sold the five-acre lot for $150,000 to the B.C. Gas and Electrical Company, who intended to eventually construct there a steam power facility. A shantytown of squatters overlaid the economically dormant site with its various salvaged shelters. In 1935 the land was leased by the City of Vancouver from the electric company for $1 annually, and gradually cleared of squatters. Relief workers constructed a $21,000 outdoor cement tidal pool. The only waterfront parkland in the eastern, working class part of the city, Windermere Pool was the result of extensive community lobbying and a civic government still operating under the regionally equitable ward system. In 1942 users of the new pool became subject to the first racial exclusion policy on Vancouver parkland. Japanese Canadians, detained in the animal stables of the nearby exhibition grounds prior to their internment in camps in the interior of B.C., were barred from pool use after newspapers cited average counts of 200 Japanese 'nationals' in the 1,000-person pool. In 1950 the city bought the land outright for $56,000, acquiring also a disused millsite immediately to the east for an additional $25,000. In 1964, under the Parks Reclamation Programme, a successful application was made to the federal government for a lease to extend the site foreshore with infill. In 1970 a much smaller swimming pool replaced the tidal pool, now contaminated with industrial effluent and sewage from a nearby outflow pipe. City Hall, no longer regionally representative, had refused to approve the requested reconstruction budget.

The site continues to propagate itself from the insecurity of broken cement chucks and other refuse of elsewhere; in 1999, further infill work was carried out, to supplement parkland gouged by the new truck route. A mostly unused foreshore promenade curves along the reclaimed land. Truant patches of comfrey and mint mark long-disappeared shanty gardens. Crab traps hang from the pier and early morning salvagers comb the rough little beaches. Deep Creek trickles out from a rotting wooden culvert.

The spatio-economic system of Lot 26 functions as a mutating lens: never a settlement, always already a zone of leisured flows and their minor intensifications, a zone of racialization and morphogenesis. On the calm surface of the swimming pool in winter, a village of geese. Structure here is anti-metaphoric: it disperses convention.

Soft Architects believe that this site demonstrates the best possible use of an urban origin: Change its name repeatedly. Burn it down. From the rubble confect a prosthetic pleasure-ground; with fluent obliviousness, picnic there.

SOURCES

Curnoe, Greg. *Deeds/Abstracts: The History of a London Lot*. London, Ontario: Brick Books, 1995.

MacDonald, Bruce. *Vancouver: A Visual History*. Vancouver, B.C.: Talonbooks, 1992.

New Brighton Centenary Committee. *Everything Started at Hastings*. Vancouver, B.C.: The Committee, 1967.

The Office for Metropolitan Architecture, Rem Koolhaas and Bruce Mau. *S, M, L, XL*. New York: Monacelli Press, 1995.

Wright, Patrick. *A Journey Through Ruins*. London: Flamingo, 1993.

The Fountain Transcript

Dossier:

 Fountain postcards by

 Hadley + Maxwell

Winter 2000. Artist Allyson Clay curated a panel of talks on the idea of the city, at Vancouver Art Gallery. The Office undertook a walking survey of Vancouver's public fountains, then studied fountain-related documents at the city archives. A silent projection of Kenneth Anger's film Eaux d'Artifices *accompanied a public presentation of findings.*

Vancouver

VANCOUVER *Public Library*

In Vancouver... and dreaming of you!

We enjoy compiling the slender catalogue of our city's modesty. The challenge is bracing. Where, but at nodes of public modesty, may a style or a politics pause to annihilate and build itself? Surfaces inflect our gestures. And vice versa. Each belief is an extension of a rhetorical space. Piety now tends towards a webbed abstraction of vastness. The uniformly repeating screens of the emporia, with their shoddy articulations and moot committees and mysteriously interesting entrances and pedagogies and cherubic greeters, exude that bored cheer that can only reflect a collective diminishment. Modesty counters this diminishment. On our civic peninsula modesty always becomes potently ironic. Beneath the blue vaults of the market we prefer to seek out little-remarked aquatic manifestations in order to notice the emblematic potentials of moving liquid and light.

A person may have a profession or employment. Nevertheless, so much is patterning of domesticity – linoleum, leaf shadow, book spine. Most citizens wash cups. We're dumped into these sketched spaces by whatever. Psychology pours from our objects. Thus, when we are strolling we wish to abandon salubrious habit to better welcome spontaneous transitions to collective states. For a while at least we shrug off the theology of extravagance. Tiny causes inflate to become secret festivals. The artful redirection of liquidity may seem like a small thing – after all, what status do today's theorists grant fountains? – but for us, rising jets, downward falls, combinations, an oddly issuing spray, divert attention from the great constant impersonal desires so that we may notice and enjoy the supple nap and receptivity of

human thought. Light and gaiety and movement stimulate our civic thirsts. Since generally indoors we are quarrelsome and demanding, we wish for an air of fête and refreshment in the streets and squares. The lovely splash of blue-white water on sculptured stone makes the whole city sparkle. Aquatic architectures alleviate our cares so that we may begin to annotate what our bodies can do with time.

Why are our fountains not truly bombastic, like their Baroque counterparts in the great European capitals and gardens? Is it because of the scale of the weather? The snowy cordillera? The Pacific? A deliberately affected nonchalance, as in our fleecy sartorial style? Downtown in the economic district, each fountain's site is clandestinely scooped from the monetary grid, hidden among corporations, rather than symbolically radiating a public logic of civic identity and access as in Paris or Rome. Here the water features seem gently irrelevant, or relevant only as cheerful prosthetics to the atmosphere of the logo. At the sparkling edges of pedestrian consciousness they dribble and froth. They are corporate fantasies. Yet stylistically these fountains' nostalgia is not for omniscience but for unfashionable, minor happiness; in this sense they flood the grid with its countertext. Why shouldn't we seek to describe happiness? And if we do, we will find that although happiness is never merely private, often its occurrence relates to the scale of our body. Here we can locate the operative conundrum: If the expressive intent of the corporate fountain is at least residually logocentric, its rhetoric always frivolously exceeds or overflows identity's names. At the

same time its personable scale is dwarfed by the immovable civic superstructures. In spite of intention, it seems that our fountains can't be monuments. After initial excursions among the office buildings and little parks and squares, we are delighted to discover that the modest water features of our city are not planned civic expenditures but mostly private or corporate gifts. It is the unique fate of the gift to be consistently misinterpreted by the receiver.

The potential of these fountains seems to draw towards it a verbal rhetoric of heightened politesse, as if the speaker or writer is invisibly bewigged, powdered, about to perform a minuet. Says a report by the Women's Centennial Committee of Vancouver in 1966 (donors of the famously spraying stainless steel crab at the Planetarium), 'To bring together architecture and sculpture, and weave them around a theme of water, is to symbolize Vancouver in the most profound manner possible.' Is water a diversion that ritually formalizes the grammatical symmetry between built form and the idea of the city? We enjoy thinking of our peninsula as a sort of liquid-filled decorative paperweight. The archive abounds in such ritual niceties. Documents there represent a dreamily democratic polis where citizens walk about and freely linger at the cafés along the commercial streets, where neighbours meet and chat over drinking fountains at lunchtime or coffee break, where 'unconventional' lifestyles add vitality to the streets, where the day is a tissue of little social relaxations and enhancements. In this archival city, to sit, to relax, to walk, to find relief, are public actions. In a mood of such civic insouciance we

open the file called 'Flags, Forest fires, Fountains, Gifts, Golf, Inaccuracies, Indian place names, Monuments, and Memorials.'

In April 1959, a local newspaper reported, 'A generous and thoughtful lady, the late Mary Eleanor Stewart left the city … $5,000 for the purpose of erecting a fountain at Victory Square … I for one am consumed with hope that something fine will result. I would dearly like to see the parks board arrange a competition among the sculptors of this city with a view to coming up with something truly original … We are so woefully lacking in such amenities which do so much to give personality to a city and help atone for everlasting commercialism, chrome, cement and unsightly car parking, not to mention untidy lots and dump-like mounds.' In the modern seats of the reading room we ponder deeply, attempting and failing to recall the image of a fountain at Victory Square Park. We feel the energetic thrill of the discovery of a hidden injustice. We would bring the public eye to this scandalous matter of the disappearance of Mary Eleanor Stewart's fountain bequest. What a disappointment it was, then, already having recruited several people to the cause, when later walking at said park we saw there a drinking fountain embellished with a plaque displaying Mrs. Stewart's now-familiar name. It was polished black granite, four-headed, canted gently outwards, with precisely elliptical basins, very grand as far as drinking fountains go. We bent to drink from it, and the fountain was dry. But then the category of fountains opened. Many would be invisible, phatic, fountains we passed daily but could not recall, dormant, removed, seasonal, lapsed, somewhat shy or retiring or

spurting contrary to intention. Our fountains would possess pathos. They would be wallflowers.

Beside the Hydro building, a faux-romantic brook. At Barclay Park, in a rounded pool, a $12,000 reconstituted marble gurgling basin backed with rhododendrons (as specified and overseen by the donor Miss Wilkinson Brighouse in 1986). At 666 Burrard, the marvelous sunken grotto of foaming triangulated brick, the air swaying, the infant grove, the screen of moving foliage above. Across the arterial an indigenous planting of horsetails and fernage beside modernity's trickling pelvic bronzework. At Erickson's courthouse the perpetually expressive Turneresque fogs trapped in the glass support of the dormant curtain of water. Raised pools reflecting the skewed grid of the failing biblio-super-store. The demure fountaining bronze fish of Water Street. The silent neon downpour of the old Niagara hotel. The entire dribbling corridor of Dunsmuir Street, from the Georgia viaduct to Coal Harbour. Corporate fountains drooling goofily. Public fools.

Some fountains are wigs and some are crinolines. Some fountains are aleatory grottos or downspouts. For example, our leaky condominiums, with names like Villa D'Este, or our retail awnings. Although they are not truly enjoyable in the ludic sense, we mention them for the charm of surprise. Even at Tivoli in ancient times, those at their recreations could be caught deliciously unawares by an errant squirt, a mobile cloud of spray. Although any water garden should welcome aleatory components, these must not be permitted to dominate. The day's mood is no longer gothic.

There are fountains that imitate the pure physiology of laughter and fountains that want us to act like knowledge. There are fountains that play between standards so deeply seductive and there are fountains of rawness, fountains of spit, fountains of dictionaries. There is the great dormant fountain of social parity in the dry square of a besieged city we spoke of on the telephone. It is in our city also. There are fountains of fashion's superfluities and they are human and we research among them. There are louche indoor fountains that secretly compose our gestures, magnetic, scholarly and intimate, and there are those whose controlled eruptions of flooding strive to end our pastoral tensions. It has not been difficult to avoid them. Nevertheless, flow in itself, with its fatal grandeur, does not interest us; we prefer to describe obstacles to flow, little impediments, affect-mechanisms, miniaturizations of sublimity. In a certain way we adore each century through its impediments and fountains as also we can now feel an agreeably improper affection for the corporate grid.

We have set out to sketch the terrain of a future analysis. It is not yet the time to present findings. Our method will compile the synthesis of bodily intuitions, historical research, friendship and chance. Music and food will also play a part. We intend to eat in the restaurant called Rain. We do expect that each of these economies will find its antithesis in a fountain somewhere, that inquiry will erupt from its own methodological grid like syllables from our teeth and lips. We expect to be deliriously misinterpreted. We fountain, always astonished by the political physiology of laughter.

SOURCES

Andreotti, Libero, ed. *Theory of the Dérive and Other Situationist Writings on the City*. Barcelona: Museu d'Art Contemporani, 1996.

Dickens, Charles. *The Pickwick Papers*. London: Penguin, 1986.

Huizinga, Johans. *Homo Ludens: A Study of the Play Element in Culture*. Boston: Beacon Press, 1955.

Lefebvre, Henri. *The Production of Space*. Trans. Donald Nicholson-Smith. Oxford, England, and Cambridge, Mass.: Blackwell, 1991.

Sussman, Elisabeth, ed. *On the Passage of a Few People Through a Rather Brief Moment in Time: The Situationist International, 1957–1972*. Cambridge, Mass., and London: MIT Press, 1989.

Introduction to *The Weather*

Dossier:

 Illustration by
 Robin Mitchell

*Fall 2000. Rolf Maurer of New Star Books (Vancouver) asked the
Office to compose an introduction to a book of poetry,* The Weather,
by Lisa Robertson.

We think of the design and construction of weather description as important decorative work. What shall our new ornaments be? How should we adorn mortality now? This is a serious political question. Sincerity's eroticism is different from wit's. The narcotic and the cosmetic each distribute a space. They sculpt what rhythmed peace could be. Within that chiaroscuro we need to gently augment the fraught happiness of our temporary commons by insisting on utopian delusion as a passage – like a wet pergola or a triumphal arch against blue. The days ever and again are godlets swagging our bliss and ignorance and adjustments in economy. We would, with ultra-enriched and devoted femininity, decorate for them. The day is our house. Words are fleshy ducts. Description decorates. As for us, we like a touch of kitsch in each room to juice up or pinken the clean lines of the possible. This décor receives futurity as its own ludic production; this weather is the vestibule to something fountaining newly and crucially and yet indiscernibly beyond. Perhaps here we shall be other than the administrators of poverty.

Consider that we need to drink deeply from convention under faithfully lighthearted circumstances in order to integrate the weather, boredom utopic, with waking life. By 'integrate' we mean: to arc into a space without surface as if it were an inhabitable, flickering event. And by 'convention' we refer to our immodest infiltration of the long citations of grooming, intimacy and prognostication. Like flags or vanes, we signify an incommensurability. No elegance is self-sufficient. No one is old enough to die or to love. The weather is a stretchy, elaborate, delicate

trapeze, an abstract and intact conveyance to the genuine future, which is also now. Mount its silky rope in ancient makeup and polished muscle to know the idea of tempo as real.

But the history of the atmosphere is recklessly slow. Recall the peculiar feeling of lassitude before a storm. This is what makes 1 a.m., 4 a.m., 5:15 a.m.: Dear Reader – A lady speaking to you from the motion of her own mind is always multiple. Enough of the least. We want to be believed.

SOURCES

Abrioux, Yves. *Ian Hamilton Finlay: A Visual Primer*. Cambridge, Mass.: MIT Press, 1992.

Benjamin, Walter. *The Arcades Project*. Cambridge, Mass., and London: Harvard University Press, 1999.

Doris, Stacy. *Conference*. Boston: Potes and Poets Press, 2001.

Grosz, Elizabeth. *Becomings: Explorations in Time, Memory, and Futures*. Ithaca and London: Cornell University Press, 1999.

Spatial Synthetics:
A Theory

Dossier:

Pompom by
Kathy Slade

Winter 2001. Composed for a special issue of Mix *magazine called*
'Popular Synthetics.'

We want an intelligence that's tall and silver, oblique and black, purring and amplifying its décor; a thin thing, a long thing, a hundred videos, a boutique. Because we are both passive and independent, we need to theorize. We are studying the synthesis of sincerity, the synthetics of space, because they are irreducible and contingent. We are shirking the anxiety of origin because we can. We want to really exercise fate with extremely normal things such as our mind.

A city is a flat massive thing already. We're out at the end of a lane looking south with normal eyes. Here is what we already know: the flesh is lovely and we abhor the prudery of monuments. But a pavilion is good. We believe a synthetic pavilion is really very good. Access would be no problem since we really enjoy our minds. Everything is something. The popular isn't pre-existent. It's not etiquette. We try to remember that we are always becoming popular.

Spatial synthetics irreparably exceed their own structure. For example: Looking west, looking west, looking east by northeast, looking northwest, looking northeast, looking west, loading wool, looking west, looking north, looking east, looking west, looking north, looking northeast, looking northeast, looking west, looking west, looking west, tracks are oldest, looking south, looking north, looking north, looking east, looking west, looking west by southwest; thus, space. And not by means other than the gestural. Pretty eyes. Winds.

Now the entire aim of our speculative cognition amplifies the synthetic principle. Everything glimmers, delights, fades,

goes. We drift through the cognition with exceptional grace. Attached as we are to the senses, we manifest the sheer porousness of boutiques. The boutiques are categories. We have plenty of time. The problem is not how to stop the flow of items and surfaces in order to stabilize space, but how to articulate the politics of their passage. Every culture is the terrible gush of its splendid outward forms.

Although some of us love its common and at times accidental beauty, we're truly exhausted by identity. Then we sink to the ground and demand to be entertained. We want to design new love for you because we are hungry for imprudent, sensational, immodest, revolutionary public gorgeousness. We need dignity and texture and fountains. What is the structure of freedom? It is entirely synthetic.

The most pleasing civic object would be erotic hope. What could be more beautiful than to compile it with our minds, converting complicity to synthesis? A synthetics of space improvises unthought shape. Suppose we no longer call it identity. Spatial synthetics cease to enumerate how we have failed. Enough dialectical stuttering. We propose a theoretical device that amplifies the cognition of thresholds. It would add to the body the vertiginously unthinkable. That is, a pavilion.

SOURCES

Arakawa, and Madeline Gins. *Reversible Destiny*. New York: Guggenheim Museum, 1997.

Bachelard, Gaston. *The Poetics of Space*. Trans. Maria Jolas. Boston: Beacon Press, 1994.

Crompton, Dennis, ed. *Concerning Archigram*. London: Archigram Archives, 1999.

Lyon, Janet. *Manifestoes: Provocations of the Modern*. Ithaca and London: Cornell University Press, 1999.

Arts and Crafts
in Burnaby:
A Congenial Soil

Dossier:

> Archival photographs from the collection of
> Jim Wolf

Fall 2000. Grant Arnold of the Vancouver Art Gallery asked the Office to prepare an essay concerning early British Columbian Modernism, for an issue of Collapse. *Prior research on the Arts and Crafts–era Ceperly Mansion in Burnaby led the Office to investigate the design history of that site, which had begun as a strawberry farm.*

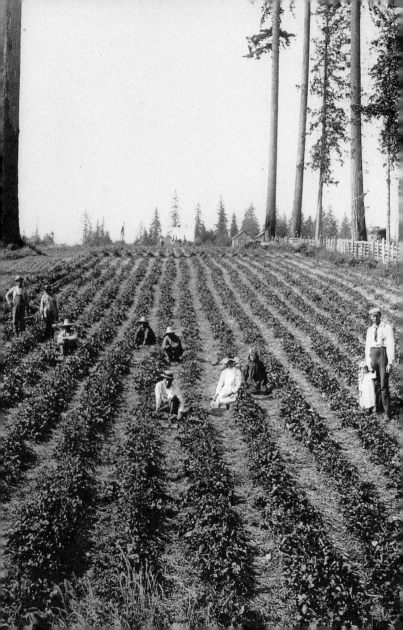

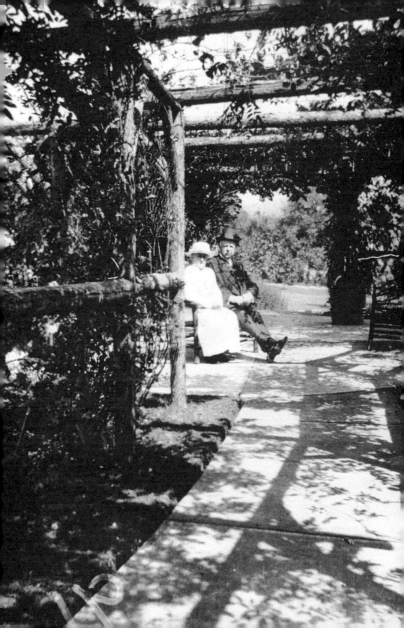

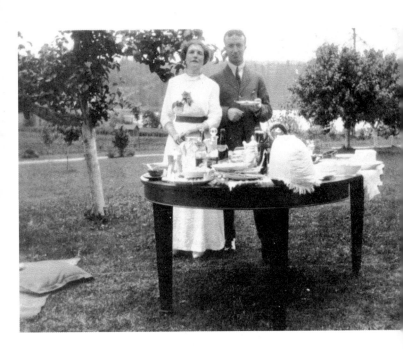

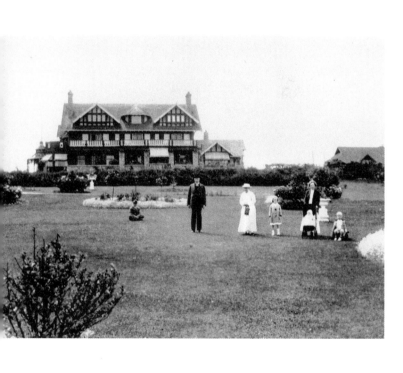

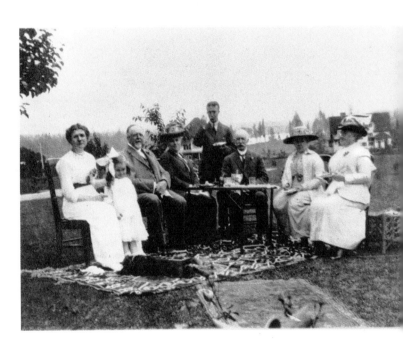

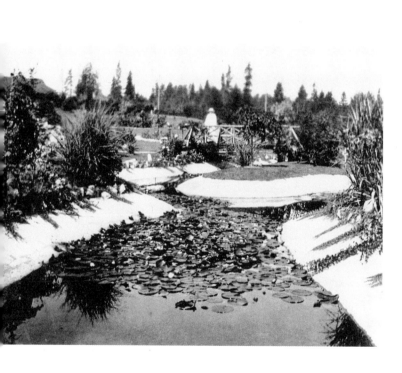

Strawberries are one of the fruits of modernity.

— Jane Grigson

'Come, and eat my strawberries. They are ripening fast,' the bachelor Mr. Knightley says, offering a casual invitation to visit his country estate in Jane Austen's *Emma*. In 1816 the strawberry was slightly fresh. But the socially ambitious Mrs. Elton crushes nuance with her hectic plans for a fashionable picnic.

'Nothing can be more simple, you see … There is to be no form or parade – a sort of gypsy party. – We are to walk about your gardens, and gather the strawberries ourselves, and sit under trees; – and whatever else you might like to provide, it is to be all out of doors – a table spread in the shade you know. Everything as natural and simple as possible. Is that not your idea?'

'Not quite. My idea of the simple and the natural will be to have the table spread in the dining-room. The nature and the simplicity of gentlemen and ladies, with their servants and furniture, I think is best observed by meals within doors. When you are tired of eating strawberries in the garden, there shall be cold meat in the house.'[1]

Here is Englishness. The stubbornly genteel and the vigorously wholesome spar lightly over the strawberry patch. Two class ideals of pastoral simplicity declare their respective spaces, their rituals, their accoutrements, and their nourishment. Mr. Knightley's haughty preference for the less vulnerable nature of the furnished, and attended, dining room seems fusty next to the

Watteauesque frolics painted by Mrs. Elton, but in the long run, human frailty beneath the weather surpasses that of the faddish strawberry.

'Mrs. Elton, in all her apparatus of happiness, her large bonnet and her basket, was very ready to lead the way in gathering, accepting, or talking – strawberries, and only strawberries, could now be thought or spoken of. – 'The best fruit in England – everybody's favourite – always wholesome. – These the finest beds and finest sorts. – Delightful to gather for one's self – the only way of really enjoying them. – Morning decidedly the best time – never tired – every sort good – hautboy infinitely superior – no comparison – the others hardly eatable – hautboys very scarce – Chili preferred – white wood finest flavour of all – price of strawberries in London – abundance about Bristol – Maple grove – cultivation – beds when to be renewed – gardeners thinking exactly different – no general rule – gardeners never to be put out of their way – delicious fruit – only too rich to be eaten much of – inferior to cherries – currants more refreshing – only objection to gathering strawberries the stooping – glaring sun – tired to death – could bear it no longer – must go and sit in the shade."[2]

But this was before the democratization of the racy fruit. Jane Austen's acerbic sketch of the strawberry picnic portrayed a middle class self-consciously grasping at a briseable symbolic; less than fifty years later new robust varieties and the advent of the railway made this stylish and desired berry of privileged rural leisure the most profitable and most cultivated market fruit in North America.

A chance hybridization of New World bounty in Louis XV's kitchen gardens at Versailles had resulted in Modernity's strawberry. Old world *hautbois* had been diminutive wild things to be plucked and sampled at the borders of forests. Domestication proved pointless. The wild berries would not thrive under cultivation. Then in the King's experimental plots the tiny, delicate, indigenous meadow fruits of Atlantic America combined their unsurpassable perfume with the firm-fleshed, walnut-sized Chilean berry. With this new hybrid the garden cultivation of strawberries entered fashion. But well into the nineteenth century the strawberry remained a vulnerable fruit, best eaten alfresco from the gentleman's vine, a gentle symbol of leisurely, pastoral pleasures and lands. Then the development of transportation networks and controlled horticultural hybridization techniques transformed the strawberry from luxury to cash crop.[3]

The strawberries of British Columbia's Burnaby Valley, renowned for their yield, size and taste, commanded in the markets of Vancouver and New Westminster a profitable two dollars a crate in 1909 when Vancouver's *Daily Province* ran a full-page feature on the new suburb. Under the headline 'Beautiful Burnaby Valley Reminder of Delightful Spots in Rural England,' a purple journalese trilled, 'Burnaby Lake seems more like a reach of the Thames than a lake ... and the lake will probably become the Henley of Vancouver as the three-mile course is perfect for rowing eight-oared races. A regatta held on these waters would be a brilliant spectacle.'[4] Hedgerows, fertile gardens, daffodil fields, sublime views and picturesquely winding

roads are among the features of ethnic nostalgia evoked along-side modern amenities such as installed bathrooms, daily newspaper delivery, telephones, electric light, profitable strawberry yields and a post office. The B.C. Electric Railway tramline to Burnaby neared completion. The valley was for sale; according to real estate advertisements in the *Daily Province*, for $50 down, balance at $10 monthly, a parcel of the allegory of England – Austen's 'English verdure, English culture, English comfort, seen under a sun bright but not oppressive' could belong to any would-be gentleman.

In 1909 Henry Ceperley and his wife, Grace Dixon, purchased a twenty-acre strawberry farm on Burnaby Valley's Deer Lake. They chose the site both for its lucrative crop and for its spectacular overlook on the Thames-like view. Ceperley was a successful Vancouver businessman; the strawberry farm, renamed Fairacres, would be the site of their retirement home. Plans began for a ten-acre landscape garden, outbuildings, including stables, greenhouses and a gardener's cottage, and the family house, costing $150,000.[5] That the Ceperleys chose to lay out their garden and build their home in the Arts and Crafts style was not radical for their time or social standing. The socialist aesthetic philosophy of John Ruskin and William Morris had become – through half a century of lifestyle periodicals, how-to books, lecture tours, department stores and middle-class leisure – a marketable, upscale commodity throughout Great Britain and its colonies. Across Canada at the turn of the century, Arts and Crafts, or Queen Anne style, offered a domestic architectural

vocabulary for both the urban and the country homes of the upper middle classes. Writing in the trade periodical *The Canadian Architect and Builder* in 1902, Vancouver architect Robert McKay Fripp[6] (who later would be involved in the planning of Fairacres), noted that 'the influence of the modern English school … has rooted deeply in a congenial soil … and will doubtless greatly thrive in the near future.'[7] Fripp recommended that the new modern style would differentiate Canadian architecture from American colonialism, with its neoclassical colonnades and Palladian porticoes. In Canadian Arts and Crafts houses, half-timbering, steeply peaked and gabled roofs, broad verandahs and sleeping porches, leaded and stained glass windows, exposed interior beams and open stairways and hearths, evoked images of a romanticized England and its vernacular architecture. In England the style developed as one part of an integrated aesthetic movement, borrowing from specifically recognizable regional architectural traditions. Although the movement's stylistic vocabulary was historically referential, in Canada the restrained use of detail and careful consideration of material, structure and siting in these houses was new. Fripp described how 'a simple and dignified effect may be gained entirely by means of good lines, careful grouping, and clever fenestration; all the detail being thought out and applied with a sparing and subtle hand.'[8] Transplanted from the English countryside to Canada's suburbs, these gently rambling homes were monuments to the economic and cultural authority of an ascendant business class who wished their houses to express a culturally authoritative, pastoral

Englishness – no-nonsense practicality, deep tradition and fond ties to nature. What this architecture largely left behind in its translation to Canada was its original integration with a politically radical aesthetic ideology, and its contextual closeness to English regional building traditions.

The English Arts and Crafts movement re-animated indigenous northern building styles, gardening traditions, decorative and homemaking practices, and craft forms. Promoting an integrative architectural approach to the decorative and household arts, and a merging of aesthetic appreciation and pedagogy into every aspect of domestic life, the early proponents of the Arts and Crafts movement coined the notion of lifestyle as a distinct aesthetic category and a commodity. Where the rural working class was seen to have a daily life, with all of that term's connotations of repetition, boredom, custom, and work, the aesthetic classes adapted from them stylistic tropes and material practices, collaging from these borrowings a 'lifestyle' which bore the signs and accessories of rural authenticity and the privileged agencies of moneyed choice. But in the movement's early stages, a vigorous anti-capitalist ideology motivated the new design aesthetic. In 'Making the Best of It,' one of his many published lectures on design philosophy, William Morris promoted his 'lurking hope to stir up both others and myself to discontent with and rebellion against things as they are, clinging to further hope that our discontent may be fruitful and our rebellion steadfast, at least to the end of our own lives, since we believe that we are rebels not against the laws of Nature, but the customs of folly.'[9] For Morris,

'the customs of folly' were competitive commerce and the division of labour. He intended the Arts and Crafts to ameliorate the alienation of workers from 'the field of human culture' by reconstructing a holistic productive environment for objects that would bear their makers' full intelligence, imagination, and skill. Workers needed not only money, but also leisure and art and praise. Morris's utopian rhetoric flowed; he anticipated the day that would bring 'the visible token of art rising like the sun from below – when it is no longer a justly despised whim of the rich, or a lazy habit of the so-called educated, but a thing that labour begins to crave as a necessity, even as labour is a necessity for all men …'[10] The new movement strove to reinhabit (one is tempted to say redecorate) an English radical workers' history extending from Watt Tyler and Cromwell to Marx; but Morris's was to be a soft rebellion, implemented by art, rhetoric and consumption. Lifestyle became an ethical category.

Nature was the pattern book for Arts and Craft ideology. As Morris expressed it, 'what else can you refer people to, or what else is there which everybody can understand?'[11] His tone was not ironical. The Romantic movement of the eighteenth and early nineteenth centuries had constructed an idea of Nature as democratic and populist metaphor, the universal paradigm of sincerity and authenticity. Revolutionary ideals of nature became popular not only among a political and cultural elite, but through the growing middle-class reading public that was reached by the mass distribution of the new literature of Rousseau, Wordsworth and the English Romantics, and Goethe. The

Romantics, in part through their decontextualization of vernacular and folk usages and contents, and their construction of new individualist metaphors of subjectivity, made a Nature that would function as foundation for aesthetic practice conceived as radical subjective agency. 'Natural man is entirely for himself,' Rousseau states in his pedagogical tract *Emile*. 'He is numerical unity, the absolute whole which is relative only to itself or its kind. Civil man is only a fractional unity dependent on the denominator.'[12] Nature was reclaimed from the shifting artifices of eighteenth-century court pastoral, from ironic citational practices and equivocal interreferentiality, to serve the Romantic myths of 'origin,' 'autonomy' and 'authenticity.' The garden received the imprint of these contemporary ideals of nature.

In England, garden design had developed into a richly coded practice that charted developing national ideals of nature and 'the land.' Through quotation of landscape painting and classical poetry, manipulation of plant materials, water and grade, and changing articulations of scale, enclosure and geometry, in images that ranged from the mannered and Italianate artifice of the baroque parterre to the gentle ruins and glowing distances of Claude Lorraine's mythic landscapes, the gardens of English gentry expressed the movement of dominant cultural imaginations of nature towards the infinity of the neoclassical landscape. By the eighteenth century England was at the avant-garde of European garden design. A handful of gardeners – William Kent, Vanbrugh, Capability Brown – and their aristocratic patrons together dissolved the traditional boundaries and forms

of the garden enclosure. They erased the geometrical symmetries of parterres and the visual obstruction of fences, and sometimes even villages, to construct for the huge country estates of the gentry an image of a benign mythic utopia, wherein, as Alexander Pope wrote in *Windsor Forest*, 'order in variety we see, / And where, though all things differ, all agree.' Fastidiously situated groves were reflected in the serpentine waters of artificial lakes; manors were aligned to views of recently constructed 'ruins'; urns, statues and inscriptions quoted classical poets; house façades were refaced as classical temple porticoes; the countryside became a metaphor for a broad comparison of English and Greco-Roman practices of Empire.[13] In compositional terms, William Kent elided the boundary between the garden as an enclosed space and the surrounding landscape, extending the designed vista to the horizon. The visual impression was of unbroken expanse, the vista replicating the unbroken power of aristocratic ownership. Capability Brown, Kent's successor in landscape innovation, stripped the expanded landscape of extraneous cultural allusion, removing temples and other referential garden architecture. Brown's minimalist expanses were composed only of elements: water, trees, land and horizon. Nature was reimagined as a field of abstract plastic forms whose sparse arrangement in heavily theorized curves and serpentines recalled the Burkean sublime. Brown blurred the representational finitudes of economy and perceptions of boundary to an unrestrained abstraction of smooth, green continuity, linking English and classical landscapes through the sophisticated

restraint of his structural vocabulary, rather than through the plenitude of figural allusion. Brown's garden was a canvas for reverie. The foreground was not a contested or problematic site; nor was the aristocratic dreamer. The rolling turf simply ended at the manor door. Looking out from the windows, all of nature appeared as one elegant and inherited composition, the horizon itself an allegory of pastoral, and national, infinity.

Gardens can receive the stamp of fashion somewhat more economically and therefore more frequently than the relatively immovable, and culturally monumental, structures of architecture. The temporality of the surface of the landscape, the ephemerality of colour, texture and fragrance, the vulnerability of plant materials to changing soil and weather conditions and cultural whims, can cause irretrievable difficulties in tracing design trajectories in individual gardens. But the development of garden writing as a popular didactic and aesthetic genre, and the proliferation of garden tracts, periodicals and books, make the nineteenth-century garden a well-documented phenomenon. The literature shows an almost rhythmic oscillation in garden design tendencies; early nineteenth-century gardeners reacted against the smoothness of Brown's neoclassical verdure, turning to a complexly ornamental picturesque influenced by fantasies of Asia, Northern 'Gothic' origins and New World wilderness. Then the enclosed, detailed geometries of the parterre entered fashion once again, now planted with newly developed hybrid annuals of subtropical provenance, prized for their timely and formal regularity in bloom and their brilliant exoticism of colour. As

gardening became popular among the bourgeoisie, the scale of gardens diminished, and the relation of garden to house was reemphasized. Composition turned inwards to decorate and complicate the boundary between the interior and nature. Humphry Repton, Brown's successor as arbiter of garden tastes, wrote in his *Fragments on the Theory and Practise of Landscape Gardening*, 'the house is no longer a huge pile standing naked on a vast grazing ground. Its walls are enriched with roses and jasmines; its apartments are perfumed with odours from flowers surrounding it on every side …'[14] Domestic organizational tropes moved outdoors as well. Gardens were organized spatially as themed 'rooms' that were 'furnished' with urns, statues and specimen trees and shrubs. Balustrades, terracing, steps and gates extended the material, social and formal vocabularies of the house into the garden, in a renewed articulation and detailing of garden foreground.

Garden structures changed concurrently – the popularity of the neoclassical allusion diminished, steel entered use, tax was lifted from glass, and in both public gardens and private estates sprawling glasshouses heated with coal furnaces sheltered the exotic fruits and trees that were part of colonialism's bounty.[15] Steel mesh was used as the infrastructure for large, blooming ornamental sculptures, which served as focal points in garden rooms.[16] The Victorian era's unquenchable desire for the new stimulus of fashion, combined with the development of both material technologies and print media marketing, influenced every aspect of garden design just as swiftly, and often as garishly, as they dictated the changing silhouettes of dresses and tailoring.

As new technologies enabled the dizzying progression of plant materials and building styles in garden design, they also helped to motivate the Arts and Crafts reaction against the market of the new. Arts and Crafts gardeners argued for the return to a cottage gardening tradition. It's difficult to judge now the extent to which the vision of the cottage garden, intimate, overcrowded, bursting with nostalgic flora, was a retrospective fantasy of cozy rural origin.[17] But this was the image that a new generation of garden proselytizers held up as an ideal of simple, authentically British vernacular design method and plantsmanship. William Robinson was at the forefront of the new movement. A Scottish gardener whose prolific writing output and impassioned rhetoric set the tone for the Arts and Crafts garden movement, Robinson's influence was formed through his books and his monthly magazine *Country Life*, as well as through design commissions. In *The Wild Garden*, he poses a convincing alternative to the Victorians' showy, carpet-bedding style plantings of annual flowers, explaining methods for the naturalization of hardy northern perennial flowers in 'woods, copses, and pleasure grounds.' Where in the eighteenth-century landscape park, Kent and Brown manipulated the human gaze, extending it beyond property boundaries into the countryside, to make of the garden a landscape, Robinson physically leaps the frame with a sack of narcissus bulbs and a trowel. He blurs the boundary between 'landscape' and 'wilderness' with flowers, flowers with specific Northern European and North American cultural meanings. Long, evocative lists of flower names in Robinson's text

serve as nostalgic litanies of the 'infinitely varied scenes … in the wilder parts of all northern and temperate regions … Such beauty may be realized in every wood and copse and shrubbery that screens our "trim gardens."'[18]

Robinson's plant naturalization techniques symbolically domesticated the rougher boundaries of the landscape, bringing forest, alpine and meadow pictures into the garden purview. Where previously landscaping had addressed the representational boundary between garden and agricultural landscape, Robinson represented the uncultivated wilderness as a garden. Now Nature aspired to the condition of presocial, Rousseauian wilds. In practical, horticultural terms Robinson contributed to a renewed general interest in hardy, nonhybrid plants and flowering bulbs. In *The English Flower Garden*, he held forth the cottage garden as a primitive design ideal, and plant source, for the old-fashioned flowers of English poetry and folklore. Engravings of vine-slung thatch gables and overgrown stone doorsteps accompanied a text that explained the practical economy of cottage-garden beauty. 'Why should the cottage garden be a picture when the gentleman's garden is not? The reason is, that one sees the plants and the vegetation not set out in any offensive geometrical or conventional plan … a plan should be subordinate to the living things.'[19] Robinson showed that 'beauty' was accessible to anyone who could root a cutting, enjoy a 'wild' picture, or appreciate and imitate the purportedly naïve aesthetics of the working class. Gardens were freed from the gentry. 'The charm of simplicity and directness' was within the compass of the middle class.

It was Gertrude Jekyll who developed these ideals and brought them into a close, practical association with the various arts encompassed by the broader movement of the Arts and Crafts. Ambitious, nearsighted daughter of a wealthy middle-class family, Jekyll used her own gardens at Munstead Wood as a testing ground for the forceful theories of colour, mixed borders, massing, wild gardening and plant craft she disseminated in her newspaper column, magazine writings, books and correspondence. Her long collaborative partnership with the architect Edwin Lutyens focused on the materials and siting of traditional Surrey dwellings. Together they developed a design style that treated the garden as a structural extension and expression of the axes and massing of the house and its site. Their gardens combined the generous and imaginative use of hardy plant species, following Robinson's model, with a rigorously conceptualized structuring of garden space that borrowed vocabularies from Humphry Repton and from Mediterranean traditions, as well as from the cottage garden. Paving, garden walls, hedges, steps, walkways, pergolas and terraces extended domestic space beyond the confines of the house. These elements were structured as garden rooms, separate stylistic enclaves that permitted the discrete mixture of various periods and styles of gardening.[20] Jekyll and Lutyens's designs achieved an expressive formal marriage of architecture with grounds, and a picturesque progression of garden scenes of differing moods, rather than re-creating any singular historical authenticity. Their work looked back to Repton's attempts to tie together house and site using

vegetation, at the same time that it referred to the cottage gardener's humble use of plants and local stone and tile. In her plant selection and grouping, Jekyll's attention to plant colour and texture was deeply informed by her training as a painter (at London's Central School of Art), and also by years of commissioned needlework and textile-based projects, wood inlay work, photography and pottery. She considered her planting as a supple drapery on the hard structure of the built garden. But her recurring concern was with the ephemeral retinal impact of colour, which she expressed with meticulous care in her writing. 'Perhaps the Grey garden is seen at its best by reaching it through the orange borders. Here the eye becomes filled and saturated with the strong red and yellow colouring. This filling with the strong, rich colouring has the natural effect of making the eye eagerly desirous for the complementary colour, so that, standing by the inner yew arch and suddenly turning to look into the grey garden, the effect is surprisingly – quite astonishingly – luminous and refreshing. One never knew before how vividly bright Ageratum could be, or Lavender, or Nepeta; even the grey-purple of Echinops appears to have a more positive colour than one's expectation would assign to it …'[21]

The gardens Jekyll designed on her own, and with Lutyens, remarkably synthesized a range of regional and historical influences and aesthetic vocabularies to create a single stylistic image that continues to dominate popular notions of the English garden. Beginning their design practise with the central precepts of Arts and Crafts philosophy – regional materials, vernacular

styles and holistic structural tropes – the two created an identifiable style whose formal integrity ironically could eclipse its own concern with regional context to become a highly marketable commodity, advertised through their commissions and Jekyll's writings, and those of their numerous followers, throughout Great Britain and in Ireland, France and North America.

Jekyll and Lutyens's articulate phrasing of site, their co-determining nexus of house and ground design, influenced generations of architects and helped determine what was to become a set of fundamental criteria for the modernist suburban house. In a 1902 editorial in the *Canadian Architect and Builder*, the relation of building to site was invoked as a basic architectural truth. 'The site prescribes the character of the building; the building aims to be as it were a part of the site; and if the architect is obliged to call in a landscape architect to enable him to understand the possibilities of the site, it goes without saying that he must base his design upon the understanding thus received.'[22] And Robert Fripp recommended, in a strong evocation of Arts and Crafts principles, 'a healthy regard for the appropriate utilization of materials and a stern refusal to countenance a cheap and flimsy mockery of detail ... let them learn to build honestly in those simple lines and measures which confer dignity of purpose ... '[23] Arts and Crafts design rhetoric formed a dominant trajectory in early twentieth century Canadian architecture; in British Columbia the development of the new suburb of Burnaby provided a timely enclave for the showcasing of this new modern architecture.

Fripp, who designed the Ceperleys' outbuildings at Fairacres, and Robert Sterling Twizell, who subsequently designed the three-storey gabled house and its garden structures, were both English-trained proponents of the Arts and Crafts style. Fripp was the president of Vancouver's Arts and Crafts Association, which, beginning in 1900, mounted annual shows of the decorative and design arts.[24] Twizell had been a Lecturer in Architecture at Newcastle-on-Tyne prior to his 1907 arrival in B.C. In 1905 he read a paper called 'The Evolution of Domestic Architecture' before the Northern Architectural Association; his concern was to give a history of the development of the typical English country house plan as it had developed from Saxon huts, Norman halls and Elizabethan manors. The paper, subsequently published in the *Journal of the Royal Institute of British Architects*,[25] is of interest in relation to his later design of the Ceperley house for its discussion of traditional materials and building techniques. Additionally, he relates a history of the gradual diversification of the early simple hall-like house plan into schema for specialized, and sometimes gender-specific, rooms, and the close relation of the structural massing of the building to these interior uses. At Fairacres the ground-floor plan consists of a long, rectangular living/dining space reflecting the traditional public 'hall' of the English manor. The smaller, private spaces radiate from this core, each legible from the exterior due to individual rooflines shedding from the central structure: to the east of the dining room the half-circular 'morning room' bays (this room corresponds, in Twizell's iconography, to the lady's 'bower' – and indeed, in the folk history of the

house, Fairacre's various mistresses are said to have claimed this room for their personal interests); to the southeast the kitchen and staff room shed out, corresponding to the ancient 'buttery' room; and to the west, off the living room, the gentleman's lounge shelters under unusually trussed beams, which appear, according to Twizell's evolutionary scheme, to be quotations of the truss structure of the earliest Saxon houses. Across the front façade of the living/dining space, and accessed by a range of French doors that break the solidity of the wall, a long, wide verandah is roofed by massive beams supported by pier-like stone columns. Not only are the various traditional social spaces of the house legible in the external structure – these spaces are rhymed in their uses by various garden structures that visually extend outwards into the site from the main axes of the house. From the line of the semi-circular morning room Twizell extended a circular rough log eating-pavilion; to the north a rustic and massive vine pergola quoted the function and structure of the verandah; off the gentleman's lounge a terrace with game board mirrored the interior leisure space. West of the lounge a 'nut walk' evoked the origin of the trussed hut in its treed landscape. Each of these exterior components echoed structures typical of the Jekyll/Lutyens garden. And, as in the Arts and Crafts garden, these spaces extended the social functions of the house outdoors across its site. This was the Edwardian era of the outdoor tea party, the formal picnic, the promenade, the children's drama in the pagoda, the croquet game and the lawn tennis volley. The various outdoor rooms opened the boundaries

of the house, encouraging family social life to decorate and animate the garden. Nature provided an intimate stage for the family; the wall, no longer the determining icon of proprieties of use, became a rhetoric.

When structure is increasingly expressed through sociality and use, rather than solely through materials, dwelling plays out an ephemeral architectural practice. Dwelling overlays and sometimes transforms the principled concepts of the designer. When Twizell left and the Ceperleys moved in, they brought with them a gardener, Mr. Legge, who tended and improved the family utopia. Snapshots reveal an inordinate fondness for terra cotta rabbits. Bunnies dotted the serene slopes of the lawns. Potted palms flanked gravel walks in a throwback to the Victorian delight in plant exoticism; a rock garden and lily pool with little bridge offered manageable domestications of picturesque ruggedness and changeability. Mr. Legge decked the good bones of Twizell's modern structure with the superfluities and inconsistencies of untrained, nostalgic, human delight. And amidst the lovely misuses of modernism, a leisurely life of family entertainments, picnics and light gardening unfolded.

In Jane Austen's England, the dining room and the garden each requested a culturally appropriate mode of domesticity or recreation. The Arts and Crafts dearticulated and mirrored boundaries, rendering these two spaces as interchangeable social sites. 'Lifestyle' spilled across the opened structures of the home; lifestyle was itself the newest recreation. In the Rousseauian Nature imagined by the Arts and Crafts garden: 'The dining

room would be everywhere – in the garden, in a boat, under a tree, or sometimes near a distant spring, on the cool, green, grass, beneath clumps of elder and hazel ... We would have the lawn for our table and chairs; the ledges of the fountain would serve as our buffet table; and the dessert would hang from trees. The dishes would be served without order; appetite would dispense with ceremony.'[26]

At Fairacres, the dining room windows were perhaps hung with William Morris's popular chintz, 'The Strawberry Thief.' Out on the lawn, the furniture and silver shone under a sun 'bright, but not oppressive.' Arts and Crafts design infiltrated and domesticated the pastoral, overlaying the site with a specifically ethnic origin myth. If the spatial chronicle of the house and garden can be considered as the gradual discorporation of the propriety of the boundary or wall, perhaps the transient and beribboned rhetoric of the picnic is the most modern of architectures.

NOTES

1 Jane Austen, *Emma* (Boston: Houghton Mifflin, 1957), 278.

2 Ibid., 280–1.

3 This small history of the strawberry is a condensation of Waverly Root's essay on that fruit in his encyclopedia *Food* (Root, 481–486).

4 *The Daily Province* (Vancouver), 12 May 1909.

5 Information regarding the history of Fairacres was recorded during conversations with Jim Wolf, City of Burnaby Heritage Planning Assistant. See also Jim Wolf, *Deer Lake Arts Centre Environmental Study, Description of Heritage Resources* (City of Burnaby, 8 May 1980).

6 Robert McKay Fripp was the brother of Thomas William Fripp, a noted watercolour painter who was born in London, England, and subsequently settled near Hatzic, British Columbia, in 1893. Thomas and Robert Fripp were among the 24 founding members of the B.C. Society of Fine Arts, with Thomas serving as the Society's first president. Thomas Fripp painted mostly landscapes, in a nineteenth-century watercolour idiom. He adopted a position in opposition to the modernism of the Group of Seven during the 1920s.

7 Robert McKay Fripp, *The Canadian Architect and Builder* (Toronto), vol. 15, 1902, 84.

8 Ibid., 84.

9 William Morris, 'Making the Best of It,' in *Hopes and Fears for Art* (London: Longmans Green, 1919), 82.

10 Ibid., 117.

11 Ibid., 111.

12 Jean-Jacques Rousseau, *Emile, or On Education*, translated by Allan Bloom (New York: Basic Books, 1979), 39.

13 In *The Genius of Place*, John Dixon Hunt and Peter Willis write in their introduction, 'There were some places where Classical and Gothick rural or native imagery co-existed, as if to designate a midpoint in the translation of Rome to England.' John Dixon Hunt and Peter Willis, *The Genius of Place: The English Landscape Garden 1620–1800* (Cambridge/London: MIT Press, 1988), 31.

14 George Plumptre, *The Garden Makers: The Great Tradition of Garden Design from 1600 to the Present Day* (New York: Random House, 1993), 85.

15 See Brent Elliot, *Victorian Gardens* (London: B.T. Batsford Ltd., 1986), 29. 'The first curvilinear freestanding [glass] house was erected … in 1827. Functional glasshouses were now a possibility from the gardener's point of view; and the key to this functionalism was in iron construction.' The relation of the gardener-designed, functional and clean-lined glasshouse to the Modernist Miesian curtain wall is unfortunately outside the parameters of my essay.

16 Elliot, 211. 'The first galvanised wire floral structure in England, 1889.' Elliot notes the formal relation of these bizarre sculptures to topiary.

17 Elliot suggests that in the idea of the humble cottage garden there was more nostalgic fantasy or false memory than historical evidence: 'There is little evidence for the existence of cottage gardens before the end of the eighteenth century.' (See Elliot, 63.) But gardens leave so little evidence that all garden historiography is in a sense a kind of Freudian dreamwork. In what season, through what representation or renovation, from what point in its development, with what persistently spreading perennial, may we retrospectively construct an image of what a garden was? And in its reimagining of nature, history and heritage, the garden itself is a constructed dream. Perhaps Freud and Jekyll's pilgrimages to Italy ought to be considered as parallel journeys.

18 William Robinson, *The Wild Garden* (London: The Garden Office, 1881), 4.

19 William Robinson, *The English Flower Garden* (London: John Murray, 1895), 8.

20 In *Gardens of a Golden Afternoon: The Story of a Partnership, Edwin Lutyens and Gertrude Jekyll* (New York: Van Nostrand Reinhold, 1982), Jane Brown provides a detailed descriptive catalogue of all of the Jekyll/Lutyens commissions.

21 Gertrude Jekyll, *Colour Schemes for the Flower Garden* (London: Country Life, 1919), 110.

22 *The Canadian Architect and Builder* (Toronto), June 1902, 82.

23 Fripp, *The Canadian Architect and Builder* (Toronto), April 1899, 78.

24 'Probably the most important event that has yet taken place in the provincial world of art is the 1st annual exhibition of the Arts and Crafts Association ... architecture, design, furniture ... all toothingly represented.' *The Canadian Architect and Builder* (Toronto), December 1900.

25 See *Journal of the Royal Institute of British Architects*, Third Series, vol. XII, no. 16, 537–548 (off-print housed at Vancouver City Archives).

26 Rousseau, 352.

Rubus Armeniacus:
A Common Architectural Motif
in the Temperate Mesophytic Region

Dossier:

Photographs by

Lloyd Center

and

Mia Cunningham

Spring 2002. Lytle Shaw of Cabinet *magazine of Brooklyn, New York asked the Office to prepare a text for a special issue on horticulture.*

The secret of improved plant breeding, apart from scientific knowledge, is Love.

– Luther Burbank

Illegitimate, superfluous, this difficult genus of frost-tolerant hermaphrodites seems capable of swallowing barns. It propagates asexually. Purplish thumb-thick stems nudge forth several feet per year. Thorns enable the plant to climb. Last year's shoot with inflorescences, this year's shoot with leaves.

In *Species Plantarum*, in 1753, Linnaeus identified two European species of *Rubus* within the large five-petalled family *Rosa*, thus beginning one of taxonomy's largest studies – batology. He described *Rubus* as polygynic: 'twenty males, many females.'

Our own relation to *Rubus* has been as jam makers rather than batologists. The sweet, plump drupelets of the *Rubus armeniacus*, or Himalayan blackberry, grow free and copious in lesser-groomed residential alleyways, vacant lots, chain-linked sites of abandoned factories and similarily disturbed landscapes of our city. Environment Canada classifies this non-native introduced taxon as a 'minor invasive alien.' It makes tasty, if somewhat seedy, pie.

In late nineteenth century America, *Rubus* enthusiasm was a faddish adjunct to horticultural orientalism – the identification and importation of Chinese brambles enriched the picturesque aspect of shrubberies, pergolas and pleasure grounds. Our favourite blackberry was introduced to this continent by the Californian entrepreneurial horticulturalist Luther Burbank in 1885. Burbank approached botanical hybridization using mass

production methods. He sought novelty, hardiness and yield – each taxon was a potential product. He selected this new bramble import, purportedly 'Himalayan' (now proven to be European in origin, by chromosome-counting taxonomic technologies) for its exuberant productivity, subjecting the alien taxon to rigorous hybridization. By crossing it with a pale indigenous bramble, Burbank would make a seemingly bleached fruit, wonder of plantsmen, 'the white blackberry,' almost disproving his own pantheistic claim that 'the human will is a weak thing beside the will of a plant.'

The Himalayan blackberry escaped. The plant's swift rhetorical trajectory from aestheticized exotic, to naturalized species, to invasive alien, all the while concealing a spurious origin myth, displays a typically hackneyed horticultural anthropomorphism. *Rubus*'s habits are also democratic. In Fordist fashion it maximized distribution through the temperate mesophytic forest region, that is, from California, up the Northwest coast as far as southwestern British Columbia, and inland to Montana. But what we have come to appreciate most about this *Rubus*, apart from the steady supply of jam, is the bracingly peri-modern tendency to garnish and swag and garland any built surface it encounters. In fact, the Himalayan blackberry insistently makes new hybrid architectures, weighing the ridgepoles of previously sturdy home garages and sheds into swaybacked grottoes, transforming chain link and barbed wire to undulant green fruiting walls, and sculpting from abandoned cement pilings Wordsworthian abbeys. We too are fascinated by its morphological lust.

After some study the Office for Soft Architecture has reached the opinion that our alien is the dystopian epitome of the romance of botanical pattern as applied architectural decoration. To illustrate our opinion we'll ramble through a picturesque landscape of quoted fragments. We'll pursue an etymology of ornament, following the *Rubus* runner back to the screen memory of the nineteenth century.

If architecture is entombed structure or *thanatos*, ornament is the frontier of the surface. It is at the surface where lively variability takes place. The architect Gottfried Semper said of the biologist Cuvier's display of comparative anatomy at Le Jardin des Plantes in Paris, 'We see progressing nature, with all its variety and immense richness, most sparing and economical in its fundamental forms and motives. We see the same skeleton repeating itself continuously but with innumerable variations.' The Office for Soft Architecture finds the chaos of variation beautiful. We believe that structure or fundament itself, in its inert eternity, has already been adequately documented – the same skeleton repeating itself continuously. We are grateful for these memorial documents. But the chaos of surfaces compels us towards new states of happiness. We concur with Ruskin, who in *The Stones of Venice* stated: 'We have no more to do with heavy stones and hard lines; we are going to be happy: to look round in the world and discover (in a serious manner always however, and under a sense of responsibility) what we like best in it, and to enjoy the same at our leisure: to gather it, examine it, fasten all we can of it into perishable forms, and put it where we may see it forever.

'This is to decorate architecture.'

For Ruskin, foliage, flowers and fruit, 'intended for our gathering, and for our constant delight,' are paradisial decorative motifs. And paradise has room for both parts of binary Man: 'The intelligent part of man being eminently if not chiefly displayed in the structure of his work, his affectionate part is to be displayed in its decoration.' Although Ruskin insisted on the balance of intelligent and affective tectonics, he defined balance as an orderly subordination of decoration to structure. Finally, he preferred to govern ornament. (It would be gentler to say that Ruskin's delight unconsciously mirrored taxonomic systems of subordination.) Semper, however, proposed a four-part unsubordinated architectural topology, where surface was in non-hierarchical dynamic relationship with moulded plasticity, a framework of resistance and foundational qualities. The transience and non-essential quality of the surface did not lessen its topological value. Architectural skin, with its varieties of ornament, was specifically inflected with the role of representing ways of daily living, gestural difference and plenitude. Superficies, whether woven, pigmented, glazed, plastered or carved, receive and are formed from contingent gesture. Skins express gorgeous corporal transience. Ornament is the decoration of mortality.

Nor did Cuvier participate in the subordination of surface to structure; for him sheer variability kept the surface in vibrant dialectic with structural essence: 'We find more numerous varieties in measure as we depart from the principal organs and as

we approach those of less importance; and when we arrive at the surface where the nature of things places the least essential parts – whose lesion would be the least dangerous – the number of varieties becomes so considerable that all the work of the naturalists has not yet been able to form any one sound idea on it.'

We are Naturalists of the inessential. Our work will never end. In the researches of Semper, Cuvier, Ruskin and *Rubus*, we recognize the dialectic that we believe continues to structure architectural knowledge: Modification vs. Frugality. We say Enough of the Least. The limitless modification of the skin is different from modernization – surface morphologies, as *Rubus* shows, include decay, blanketing and smothering, shedding, dissolution and penetration, and pendulous swagging and draping, as well as proliferative growth, all in contexts of environmental disturbance and contingency rather than fantasized balance.

Rubus Armeniacus is an exemplary political decoration, a nutritious ornament that clandestinely modifies infrastructural morphology. Here affect invades the centre. *Rubus* inverts and puns upon the proprietous subordination of affective expenditure to intelligence. Tracing a mortal palimpsest of potential surfaces in acutely compromised situations, *Rubus* shows us how to invent. This is the serious calling of style.

SOURCES

Anonymous. 'Chinese Brambles; for shrubberies, pergolas, and pleasure-grounds.' *Gardener's Chronicle*, March 16, 1912.

Burbank, Luther. *Luther Burbank: His Methods and Discoveries and Their Practical Application*. New York and London: Luther Burbank Press, 1914.

———. *The Training of the Human Plant*. New York: Century Co., 1922.

Darwin, Erasmus. *The Essential Writings of Erasmus Darwin*. Ed. Desmond King-Hele. London: MacGibbon and Kee, 1968.

Foucault, Michel. *The Order of Things: An Archaeology of the Human Sciences*. New York: Vintage Books, 1973.

Herrmann, Wolfgang. *Gottfried Semper: In Search of Architecture*. Cambridge, Mass.: MIT Press, 1984

Linnaeus, Carolus. *Families of Plants, with their natural characters, according to the number, figure, situation, and proportion of all the parts of fructification*. Trans. Erasmus Darwin. A Botanical Society at Lichfield, 1787.

Roger, Jacques. *Buffon: A Life in Natural History*. Trans. Sarah Lucile Bonnefoi. Ithaca and London: Cornell University Press, 1997.

Ruskin, John. *The Stones of Venice*. London: J. M. Dent and Co., 1907.

Steadman, Philip. *The Evolution of Designs: Biological Analogy and the Applied Arts*. Cambridge, England, and New York: Cambridge University Press, 1979.

How To Colour

Dossier:
Taste by
Renée Van Halm

Spring 2002. For her installation Taste, Vancouver painter Renée Van Halm had researched the history of decorative colour in twentieth-century domestic interiors, then produced ten matched colour disks for each decade. Reid Shier of the Contemporary Art Gallery in Vancouver asked the Office to prepare a catalogue text for an exhibition of her work.

00s

10s

20s

30s

40s

50s

60s

70s

80s

90s

00s

10s

20s

30s

40s

50s

60s

70s

80s

90s

We can't always tell the difference between sentiment and emotion. They marble. The fungal puce bordering the sweating window pane, the flapping cobalt tarp on the leaking condo, the intense turquoise of low-rent trim in our neighbourhood: the surface of the city indexes conditions of contamination, accident and subordination. We always dream in colour. This is part of the history of surfaces.

When Walter Benjamin visited the house of Goethe in a dream, the corridor was whitewashed. We'll stroll down that pale hallway, and apply to its purity a narrative maquillage.

Falsity is among the etymological associations of the Latin word *color*. Colour is defined as 'hue, dye; a pretence' in the 1832 miniature edition of Samuel Johnson's *Dictionary* (which also offers 'to clear' as one meaning of the verb 'to whitewash'). In his pedagogical text *The Seven Lamps of Architecture* (1848), John Ruskin advised that whitewash conveyed the meaning of innocence and sincerity, specifying that 'it shows itself for what it is, and asserts nothing of what is beneath it.' Whitewash has nothing to hide. Ruskin continues, 'Gilding has become equally innocent ... allowable to any extent.' In 1806, as Goethe wrote his *Theory of Colours* in Weimar, the city was occupied by Napoleon's troops. In that year Napoleon had changed the colour of his army's uniform from revolutionary blue to white. Russia had blocked the export of indigo to France. There was not enough blue dye to supply the army. In Weimar they marched in white uniforms with gilded buttons, a moving whitewashed corridor that prefigured Ruskin's decorative

assessment of whiteness and gilding. But white was poor for morale; it was too true and too sincere. At battle each soldier could read death on his fellow's tunic. Within the year, Napoleon decreed a return to blue uniforms, on which blood and gore and battlefilth were less alarmingly visible. He began to promote the French cultivation of woad for use as a blue dyestuff in place of indigo. Goethe wrote, 'We love to contemplate blue, not because it advances to us, but because it draws us after it,' perhaps a more agreeable persuasive rhetoric for an army to perpetuate. But the soldiers had been required to purchase white coats, and these increasingly besmirched garments could not be eradicated from the ranks, which now appeared motley, impure, random.

We wonder how white became so innocent. When Goethe claims for the colour white that in organic forms it tends to appear only in the interior, rather than on the surface, we think of the bones of a mammal or the pith of a stem. We think of Goethe's whitewashed hallway, running through Benjamin's dream like a spine. But affect can't be controlled. White proposes a disciplinary unity and it always fails. It already submits to pigment and chance. We think that by dyeing our costumes and carrying our colourful objects and cosmetics we lend mobility to the plants and deny for a while each species' propriety. The surface of us overlaps with other phyla. Walking and parading we mix the surface of the earth, though we might intend that march's purpose as ordination. Colour marks exchange. It is border-work. Mixture is our calling.

We base our assumptions on the similarity of matter but everything is mixed. Even the giant white skeleton of neoclassicism suspended in its museum could not protect us from history. It merely becomes the armature for a drapery of flags, pennants, the exposure of laundry, a Romantic screen of mist and smoke, and a rough filigree of graffiti. Here and there the bones poke through the pigment in ornamental fracture.

As a boy Sigmund Freud worshipped Heinrich Schliemann, the great archaeologist of Troy. Schliemann was a businessman who financed his excavations of the lost Homeric city by investing in the indigo trade during the Crimean War. Battlefield slaughter expanded the indigo market. The blue skin of imperial Europe supported the structural phantasy of origin. The archaeological metaphor called Troy – which informed Freud's psychoanalytic fiction of a spatially structured consciousness – was financed by the movement of pigment across contested borders. Metaphor inflates an economy. Colour is structured like a market. Both colour and market are measured combinations of sentiment and emotion. A political economy appears to contain their instability, but at any moment this structure could be flooded by the randomness of affect. Plato and Aristotle thought paint or pigment was a drug or a *pharmakon*: an occult substance that, like poetry, could stimulate unaccountable change. They wished to excise it from the polis.

The white wall is a phantasized exoskeleton, not so much a screen memory as a ghostly amnesia. Like the whitewashed mirage of an army, it dissolves as approached and the redun-

dancy of mortal pigment emerges, shot through with sullied fragments. The ad hoc semantics of pigment scumble intention. The dichotomy of colour and pigment is false and therefore instructive. For Newton, of course, all colour joined in the pure concept of whiteness, of light. But we are attracted to the weakness and impurity of the bond of pigment, because we can identify with nothing other than instability. This identification is admittedly a style of taste, but it also improvises a political alignment.

We are aligned with a surface. We exchange mineral components with an historical territory, less like cyborgs than like speaking, ambulatory dirt.

Repeatedly we have attempted to define colour for ourselves, although it is only with great difficulty that we depart from the sultry glamour of pigment. Between mysticism and glamour, we would rather not choose.

We could say juice, or pigment, to indicate that aspect of substance that travels across. Such juice is always psychotropic. It translates mentalities. We might say that pigment is that motion spontaneously produced by substance in conjunction with light. Dangerously pigment smears. Artifice is the disrespect of the propriety of borders. Emotion results. The potent surface leans into dissolution and disrupts volition – it's not a secluding membrane or limit. To experience change, we submit ourselves to the affective potential of the surface. This is the *pharmakon*: an indiscrete threshold where our bodies exchange information with an environment.

When we say juice, we mean a tinging juice, a juice which marks the surface through co-operation. Such a juice is to be found in the juice of ink, the red juice, things filled with a red juice, a concentrated juice. Armies run with juice. This juice has a property, this juice appears to be connected to phenomena. Pure red juices are common as are the juices with very rich and powerful hues. Some-thing yields a beautiful yellow juice. Flowers and their juices are bleached by sulfur. The glamorous surface is nourished by perfect juices. When we want to produce something exciting, something alluring, we begin with pigment or juice.

Colour differs from substance. Is colour always lyric? We are not sure. It seems to consist of the detritus from natural history stuck into sentiment. For example, it is said that among humans, women are colourful. Nothing more needs to be said on this theme. We want to expose colour, bring it out of the boudoir, where colour and truth are always bickering. With Goethe, 'of the internal structure we do not speak, but confine ourselves briefly to the surface.' We can't speak of a true colour, but we can indicate mineral excursions with verbal functions. Colour itself speaks, so thankfully can't be truth, which is silent and must be read. The polis is quite colourful. Each unaccountable surface ripples as if italicized. The external economy never wants to complete itself.

Colour receives belief in the form of a name. 'Blue.' It literally attaches to the architecture, cracking and splitting around it like a shell or dangling from it like capital or savage ornaments or ideals or words. It attaches to consciousness. The name bloats

and travels and drifts with arcane logics. It can appear as though colour, like an army, is made from memory and fear and lust. The names are public screens on which sentiment performs. When we walk in the inscription-splattered street we are interested to question the relation of surface to belief. This question defines our stance as citizens. Thinking about colour we open up a space in the surface, the potent space between substance and politics. A tiny freedom drifts there and we adore it. But our gluttony for the ethereal has not to do with fame or glamour or scale. Through gluttony we come to resemble history. Through gluttony we are indexical.

Aristotle said that colour is a mixture of three things: 'the light, the medium through which the light is seen, such as water and air, and thirdly, the colours forming the ground from which the light happens to be reflected.' These remain useful differentiations. The medium is also an economy. Another way of saying this is that the triad of pigment, colour, medium always trembles, and could at any instant dissolve. The idea of unstable mixture remains essential to us. The notions of colour and pigment are mixed through as though marbled by their historical medium. Like the myth of the market, they must be observed with ambivalence.

Between the popularization of archaeology in the early nineteenth century, when Napoleon brought plundered fragments of Egypt home to France, and the encroachment of Haussmanization in Paris, colour and architecture conducted a dalliance. It became the style to notice the remnants of pigment on Egyptian

and Greek ruined monuments. Pigment traces were catalogued and exhaustively described by archaeologists and architects, whose practices then included the design of decorative schemes for both interiors and outer façades. From ancient paint found on statuary and architectural façades, researchers invented a range of colourist narratives that linked antiquity to the contemporary. Colour, like consciousness, received an analytic fiction. These theories served as the support for new polychromatic architectural fantasies. A reanimated antiquity, retrieved from the eighteenth century neoclassical dream of purity, asserted its pigmentation in the architectural avant-garde of the early nineteenth century. Painted, striated, gilded and charm-decked, antiquity received gestural language, became tactile, and in turn served briefly as the authority for an architectural language of social exchange.

Between 1823 and 1830 Jacques-Ignace Hittorff researched early Greek architectural polychromy. He proposed that ancient temples had been painted using polychromatic orders analogous to the architectural orders of form. His theories of polychromy were related to aesthetic systems, rather than sociological uses. Nevertheless his popularization of the idea of polychromy and its harmonic relation to specific sites inflected the purist values of neoclassicism, so that history and architecture became contested spaces rather than serving as static ideologies. For Hittorff, polychromatic architecture responded to specific meteorological and geological contexts; colour responded to (and participated in) site. Henri Labrouste was the architect of the

Bibliothèque Sainte-Geneviève and the interior of Boullé's Bibliothèque Nationale in Paris (1839–1859). He extended the contextual field of architecture from the physical site to include the social. During his student researches in the 1820s in Rome, he developed the concept of accretive polychromy, making phantastical illustrations of classical temples whose invented decorative vocabularies evolved to reflect new social uses, as the old uses atrophied and disappeared. Signage, graffiti and ornamental fixations of objects to the walls refleshed the diminished forms of the classical. He clothed architecture with the marks of its inhabitation. At the Bibliothèque Sainte-Geneviève in Paris, he used both graffiti and structure as ornament, painting the names of 810 writers directly on the library façade, and in the Bibliothèque Nationale he decoratively exposed the lacework of iron supporting columns. German architectural historian and designer Gottfried Semper, based in Paris, absorbed the idea of polychromatic accretion and developed from it an archaeologically derived methodology of design, during studies of polychromy in Sicily, Italy and Greece in the 1830s. The flesh of the building, its cladding, for Semper referred to the archaic textile and ceramic arts that had provided the materials and techniques that divided and defined space. For Semper, architectural ornamentation should quote the tactile history of these applied decorative arts. Building structure served only as the framework for socially performative enclosure, rather than as an expression of authenticity and permanence. Ornament indexed a history of applied material and manual technique. Owen Jones, author of

The Grammar of Ornament and interior architect for Paxton's Crystal Palace in London (1851), decorated the iron and glass display centre by constructing from pigment a second, interior weather, an eastern bloom of brilliance, where narrow bands of primary colour proportioned with white combined optically to artificially generate a 'true' Mediterranean light in London, for the best contemplation and enjoyment of oriental textiles and objects. He had derived his theory of light, colour and bloom from his early study of painted colour at the Alhambra, in Spain, research that he extensively documented and published using the then new chromolithography technique.

These architects participated in a broader discourse around polychromy, a discourse radical in its articulation of European history as a spatial accretion of social and material practice. The imagined gestural trace of the archaic painter, the textile worker, the graffitist, and an accumulated history of inhabitation, entered architectural metaphor as ornament. The surface of architecture expressed a historical rhetoric of use. Surface effects were not subordinated to deeper structural ideals; rather structure partially extroverted to itself became a component in the ornamental grammar of the surface. The polychromatic surface communicated rather than suppressed corporal historicity and change.

The pigment and ornament we apply to a supporting structure stir our gesture into the surface. Application is a persuasive and pleasurable folding; the surface is comprised of bodily traces and fixations – rubbing, flecking, scrubbing, weaving, stroking

are tactile instrumentations in time. They address both substance and the future of bodies. Hence the surface poses a rhetorical index even while temporal contingency renders it partly unaccountable. We wish to face the unaccountable. In the tradition of meaning, if the idea of internal structure could be temporally expressed as the past perfect, the idea of the surface would be the future conditional. On the surface, gestural application improves or caricatures time, subjecting the temporal to the influence of contamination, accident, and subordination – sociality or neurosis, in short. It is as if colour hails us. When it does so our entire surface is concentric. We are soothed or refreshed or repelled.

It is we who have caused this stirring called colour. Nevertheless, we cannot control it. When we stumble against limits we blush. Disproportion and fragility are shameful and funny. This is ornament. Colour, like a hormone, acts across, embarrasses, seduces. It stimulates the juicy interval in which emotion and sentiment twist. We groom in that *pharmakon*. This is architecture, an applied art.

SOURCES

Aristotle. *Minor Works*. Trans. W. S. Hett. Cambridge, Mass.: Harvard University Press; London: William Heinemann Ltd., 1963.

Benjamin, Walter. *Selected Writings, Volume 2, 1927–1934*. Cambridge, Mass., and London: Harvard University Press, 1999.

Derrida, Jacques. *Dissemination*. Trans. Barbara Johnson. Chicago: The University of Chicago Press, 1981.

Goethe, Johann Wolfgang von. *Theory of Colours*. Trans. Charles Lock Eastlake. Cambridge, Mass., and London: MIT Press, 1970.

Holt, Elizabeth Gilmore, ed. *The Art of All Nations, 1850–1873: The Emerging Role of Exhibitions and Critics*. Garden City, New York: Anchor Books, 1981.

Middleton, Robin. *The Beaux Arts and Nineteenth-Century French Architecture*. Cambridge, Mass., and London: MIT Press, 1982.

Ruskin, John. *The Seven Lamps of Architecture*. New York: John W. Lovell Company, 1885.

Semper, Gottfried. *The Four Elements of Architecture and Other Writings*. Cambridge, England, and New York: Cambridge University Press, 1989.

Van Zanten, David. *The Architectural Polychromy of the 1830s*. New York: Garland Publishing, 1977.

Doubt
and the History of Scaffolding

Dossier:

Sculptures by
Elspeth Pratt
Archival photographs courtesy
Vancouver City Archives

Spring 2002. Lorna Brown of Artspeak Gallery asked the Office to contribute to a book on the sculptures of Elspeth Pratt, to accompany her exhibition Doubt. Intrigued by the disappearance of a fifteenth-century text on scaffolding, by Brunelleschi, the Office undertook to replace the missing record. Archival images and on-site observation of the perpetual renovation of Vancouver's leaky condominiums supplement the scarcity of written history on the subject.

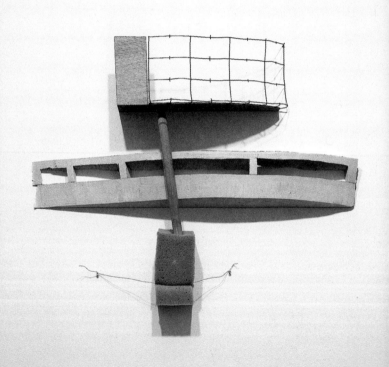

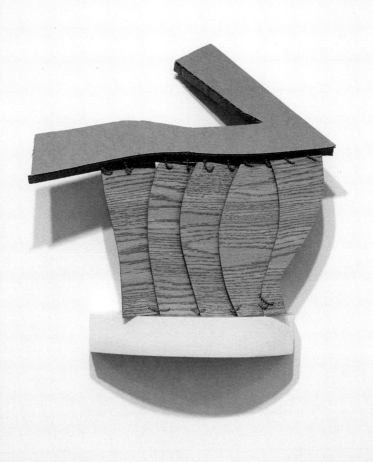

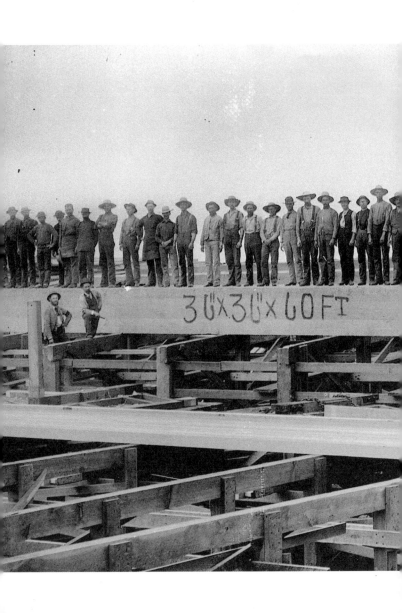

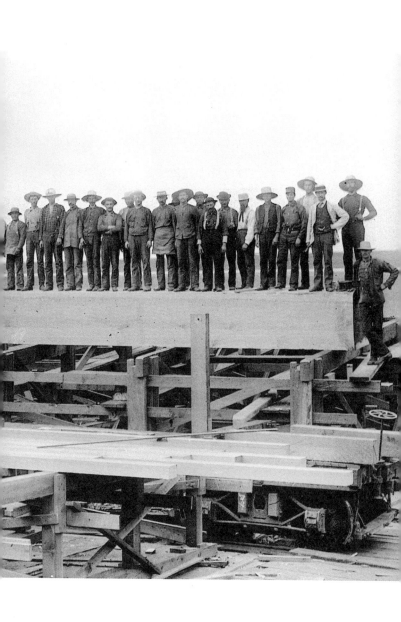

When the baby is born there is no place to put it: it is born, it will in time die, therefore there is no sense in enlarging the world by so many miles and minutes for its accommodation. A temporary scaffolding is set up for it, an altar to ephemerality – a permanent altar. This altar is the Myth. The object of the Myth is to give happiness: to help the baby pretend that what is ephemeral is permanent. It does not matter if in the course of time he discovers that all is ephemeral: so long as he can go on pretending that it is permanent he is happy.

— Laura Riding, *Anarchism Is Not Enough*

The history of scaffolding has been dismantled. We can't write this history because there are so few documents – only a slim sheaf of photographs. So we study the construction of the present and form theories. We use the alphabet as a ladder.

Scaffolding, from *scalado*, to storm by mounting a wall by ladders.

We believe that the object of architecture is to give happiness. For us this would mean the return of entropy and dissolution to the ephemeral. The architecture of happiness would rehearse a desanctification of time, which is itself only a scaffolding. We live on this temporary framework of platforms and poles, as diagrammed in the most rudimentary fashion by the letter 't.' All the ceremonies of transition take place on such a makeshift planking: judgements, executions, banquets and symposia, entertainments and recitals, markets and bazaars, funerals, births and weddings and illicit fuckings are rehearsed and performed

to their witnesses on this transient stage, which is sometimes decorated with drapes or swags or flags or garlands, sometimes padded for the comfort of the performing body, sometimes left bare as if to state the plain facts of life. The scaffold is a pause, an inflection of passage. It accommodates us in a shivering.

Planks for scaffolding should be carefully inspected and tested. Men might spring on the planks or tap them for sound. These tests are not likely to injure a good plank. Photographs of special scaffolds and other rigging interest us. In preparation for the photograph the men should arrange themselves on the scaffold as in a frieze, standing with their various brimmed hats against the sky, or sitting swinging their legs from a more supple plank with the hacked forest behind them or the bare place that will become the city. We find such an image quite attractive.

Firstly, a scaffold lists, in every way.

List, as in a record, a number, a law, a row or rows; to enter, to register, to enlist; a method, a border or bordering strip, a salvage, a strip of cloth, a stripe of colour, a ridge or furrow of earth; to produce furrows or ridges; a careening or leaning to one side, as a ship; to be pleasing, to desire, to lust. To list a narrow fillet. Listless. Enlisting cloth. A stuttering. A conceptual limp. Scaffolding is analogy. It explains what a wall is without being a wall. Perhaps it describes by desiring the wall, which is the normal method of description. But also the scaffold wants to fall away from support. Its vertigo is so lively. The style of fidelity of scaffolding is what we enjoy. It finds its stabilities in the transitions between gestures.

Rumour has it that the same designer once drew plans of temporary supporting structures alongside those of the permanent edifices. The story can be illustrated by the working drawings of ancient masonry bridges accompanied by their designated falsework. Now scaffolding floats freely, detached from the severity of an origin. It is a system, not an organism. Its repeating components follow the pattern of a drifting list. The list is the most rudimentary system. Rhythm is so elegant.

In addition to the description of its technique, which as we have said can be diagrammed by a 't,' or tipped to lean into an 'x,' there are three things to be said about scaffolding. It is a furnishing, it is a skin, and it is a grove.

'X' shows scaffolding as skin. The deep structure of the skin is intricate. It disproves the wrongheaded and habitual opposition of ornament and concept. It does act as an excitation screen but the function of skin includes a necessary psychic dimension not mediated by the conscious bodily senses. This dimension extends beyond the visual plane of the surface, as if the entire skin were spun outwards in its excitable permeability to become an ideal threshold. The scaffold works as a filter of exchange and inscription that localizes and differentiates the huge vibratory currents swathing the earth. It rhythmically expresses the vulnerability of the surface by subtracting solidity from form to make something temporarily animate. It shows us how to inhabit a surface as that surface fluctuates. Whatever change is looks something like this – a *leaning*, a consciousness *towards*, a showing *to*. We like scaffolding because, lingerie-esque, it disproves the rubric of the monad.

We could say scaffolding is a furnishing insofar as it supports the desires of our bodies. It's moveable and it faces us. We orient it to our transient needs. It has a front and a back like furnishing, and like our bodies. Like furniture it is a projection of our bodies, making us bigger, more limber, more elegant and serious. It intersects with our experience like the wave front of a dynamic system. A scaffold sketches a body letting go of proprietary expectation, or habit, in order to be questioned by change. A scaffold is almost a catastrophe. Its topography cathects with the desire to release identity and dissolve into material, which is the style of resistance we prefer. And like a wave also, scaffolding, or falsework, is not specific to a structure or a site. In each city there exists a certain proportion of falsework to fixed structure, and the scaffolding wanders among solidities, a mobile currency that accretes and dissolves and shifts according to the secret rhythms of the city's renaissance and decay. It seems somewhat hysterical. Like a civic erotogenic zone, or a form of knowledge, scaffolding diagrams change. This directional lability lends to falsework a quality of volition, in the way that the weather or money is a structure of volition. It touches us in passing, as the perpendicular of 't' passes over and notates a topology or horizon. We glimpse volition tarrying in the visible. As furnishing, the scaffold performs a direction and a regard. Its function is to face. Thus its solemnity, which is ceremonial, as is all furnishing.

As bosco, the scaffold shades with its ceremonial branchwork stimulating, covert activities such as the profound intimacy of solitude: scaffolding is the negative space of the building.

It impedes the transparency of vision. It is architecture's unconscious displayed as a temporary lacework: a garden in other words, or a kind of formal grove. When an immobile building, inevitably bored of its environment, wants a new site, a scaffolding can be constructed around it. Scaffolding substitutes for a site. By compression or condensation it transforms an atmosphere to a condition of access which is also a screen. This idea is easily inflated towards the surreal or the homeopathic, but it is based on observation. When at night we hear the scaffolding rustle, then look up to watch it sway, we feel voyeuristic longing. In darkness the scaffolding is foliage. Sometimes swinging on special leafy scaffolds we feel compelled to loose our little slipper.

When we awake near a scaffold the frieze of men is calling numbers into the morning. Thus the scaffold promises practically everything to the architect both languorous and alert. Then it disappears. As for us, we too want something that's neither inside nor outside, neither a space nor a site. In an inhabitable surface that recognizes us, we'd like to gently sway. Then we would be happy.

SOURCES

Burton, Robert. *The Anatomy of Melancholy.* New York: New York Review of Books, 2001.

Colonna, Francesco. *Hypnerotomachia Poliphili.* Trans. Joscelyn Godwin. London: Thames and Hudson, 1999.

Lefaivre, Liane. *Leon Battista Alberti's Hypnerotomachia Poliphili: Recognizing the Architectural Body in the Early Italian Renaissance.* Cambridge, Mass.: MIT Press, 1997.

Riding, Laura. *Anarchism Is Not Enough.* Berkeley: University of California Press, 2001.

Playing House:
A Brief Account of the Idea of the Shack

Dossier:

Photos archived

and installation by

Liz Magor

Summer 2002. Vancouver Art Gallery and Power Plant (Toronto) asked the Office to contribute an essay to a catalogue on the work of Liz Magor. Magor maintains an ongoing archive of photographs of West Coast shacks. In her installation Messenger she constructs a fully supplied shack inside the gallery. The Office has lived in various shacks.

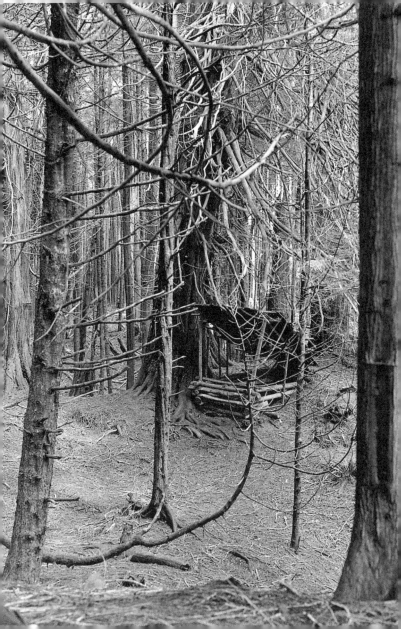

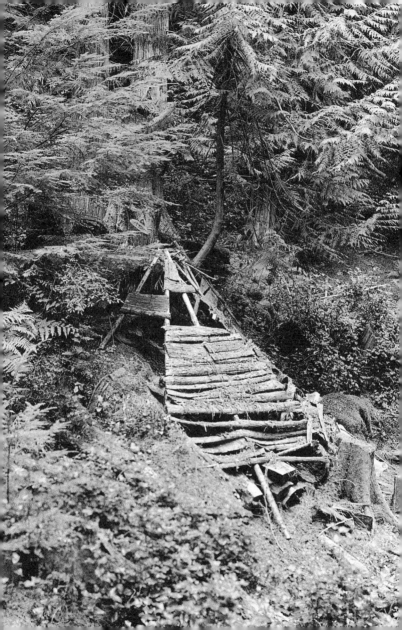

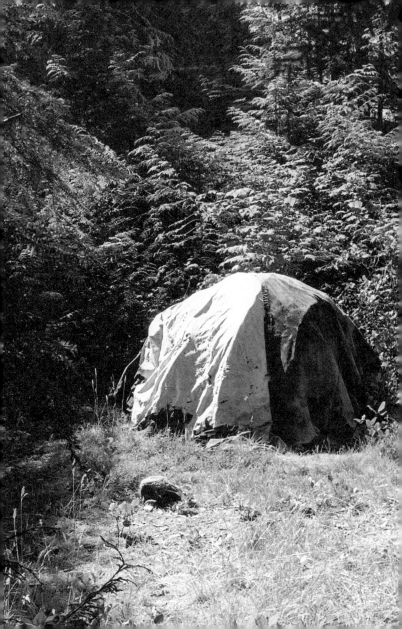

1. The subject has always just left the shack. What a shack remembers is previous shacks. Also, each shack leads to the next shack. So the shack is a series. Because we are suburban we understand shacks.

2. Literature tells us we will remember the house of our childhood, with its nooks and garrets and stairs and passages and so on, as if this house were singular, but we were born in a series. We were born in the suburbs, or our childhood was distributed across that serpentine landscape. Suburbs are recurrent dreams. Each house repeats the singular wilderness. In the suburbs we learned to understand what is virtual and now we invent the beginning, again and again. This is not nostalgia. Or, it is nostalgia turned inside out. We distribute origin across the virtual. We don't guard it. What we crave is not Rousseau's solitude but the excellent series of origin dwindling on ahead into the future. Thus we love shacks. Each leads erotically to the next. One sojourns, or starts out, rather than settles, in a shack. Domestic duration, like childhood, is transient, serial. A shack is always timely. Typically an account of the history of architecture will begin with a shack.

3. Thickets, a cave, a hut of boughs are the components of landscape that conventionally provide primordial coverage. Structurally the shack is a thickening, a concentration, an opacity in the lucid landscape. This lyric site of nature's contraction is the minimum of shelter. Laugier, the French architectural theorist

writing in 1753, followed Vitruvius and Alberti by posing the shack or hut as the first principle of architecture, the idea from which all theory extends. Filmically he described the primitive's trajectory – from repose on the idyllic lawn to the anxious retreat to cover, and ultimately to the organization of components of the landscape into architecture: 'He is in need of a place to rest. On the banks of a quietly flowing brook he notices a stretch of grass; its fresh greenness is pleasing to his eyes, its tender down invites him; he is drawn there and stretched out at leisure on the sparkling carpet, he thinks of nothing else but enjoying this sparkling gift of nature … But soon the scorching heat of the sun forces him to look for shelter. A nearby forest draws him to its cooling shade; he runs to find a refuge in its depth, and there he is content … The savage in his leafy shelter, does not know how to protect himself from the uncomfortable damp that penetrates everywhere; he creeps into a nearby cave and, finding it dry, he praises himself for his discovery. But soon the darkness and foul air surrounding him make his stay unbearable again. He leaves and is resolved to make good by his ingenuity the careless neglect of nature. He wants to make himself a dwelling that protects but does not bury him. Some fallen branches in the forest are the right material for his purpose …'[1]

Laugier tells a simple story: the retreat from lucid pleasure to protective opacity, then to willed structure. Is architecture a monument to the failure of pastoral utopia, whose greeny bliss only passes, like a tempest? The shack as first principle seems to be a protection against weather and against time.

4. The landscape includes the material detritus of previous inhabitations and economies. Typically the shack reuses or regroups things with humour and frugality. The boughs of a tree might become a roof. A shack almost always reuses windows, so that looking into or out of the shack is already part of a series, or an ecology, of looking. In this sense a shack is itself a theory: it sees through other eyes. This aspect of the shack's politics prevents shack nostalgia from becoming mere inert propaganda. The layering or abutment of historically contingent economies frames a diction or pressure that is political, political in the sense that the shack dweller is never a pure product of the independent present. He sees himself through other eyes.

5. When Thoreau gathered the materials he would need to build his shack at Walden Pond, he bought the shanty belonging to an Irish labouring family who were moving on. The Irish wife described the Irish shanty with exemplary frugality: 'good boards overhead, good boards all around, and a good window.'[2] For these good items, to be removed by small cartloads to his own site, Thoreau paid four dollars and twenty-five cents. And in his catalogue of materials he lists 'Two secondhand windows with glass … $1.25.'[3] Each shack dweller is an economist who thrives in the currency of the minimum, the currency of detritus. The economy of the shack enumerates necessity, or more exactly it enumerates a dream of necessity, using what's at hand. This improvisatory ethos is modern. It is proportioned by the utopia of improvised necessity rather than by tradition. How much

would we need? The shack is always conditional. The disposition of things is an economy in time. The shack is in flux.

6. A shack describes the relation of the minimum to freedom. We consider that the idea of the minimum, the idea of freedom, the idea of the shack, shape our beliefs. The freedom from accoutrement popularly stands as liberty. Here we sing along with Joplin's cover of 'Me and Bobby McGee,' and we understand our own youth as a pre-economic myth. Thoreau's image of prelapsarian shelter pertains to the innocence of Romanticism's child: 'We may imagine a time when, in the infancy of the human race, some enterprising mortal crept into a hollow in a rock for shelter. Every child begins the world again, to some extent, and loves to stay outdoors, even in wet and cold. It plays house, as well as horse, having an instinct for it … It was the natural yearning of that portion of our most primitive ancestor which still survived in us. From the cave we have advanced to roofs of palm leaves, of bark and boughs, of linen woven and stretched, of grass and straw, of boards and shingles, of stones and tiles. At last, we know not what it is to live in the open air, and our lives are domestic in more senses than we think. From the hearth to the field is a great distance.'[4] It is the task of the shack to minimize this distance, in the service of an image of natural liberty. We play house in shacks.

7. Thus the shack is the natural language of architecture. By natural we mean original. If architecture is writing, the shack is

speech. Like a folk song it stores a vernacular. What is the minimum necessary? What is a monad? – an elementary, unextended, individual spiritual substance from which material properties are derived. Architecture is derived from the unextended shack, as language is derived from a vernacular. Or the monad is a spiritual shack. It stores belief. Like any etymological construction, each shack is a three-dimensional modification of belief.

8. When the shack dweller lays in supplies, she is composing a politics. The shack demonstrates the site-specific continuum between belief and the perception of necessity. We like to remember that politics are collective experiments in belief. It is said that catalogues comprised the first ideological poetry. Here is a list of the contents of a particular shack: '3 saucepans, skillet, kettle, cutting board, toaster, lightbulbs, wineskin, 3 plates, 2 mugs, a thermos flask, a bed made on storage boxes, a tarnished mirror, a toothbrush glass, a cooler, a stove, a desk lamp, a medieval visored helmet and axe, a contemporary military helmet, combat clothing in camouflage fabric, a thin nylon sleeping bag, an ammunition box, a kitchen grinder, two grenades.'[5]

Thoreau, on the other hand, catalogued his shack's furnishing as follows: 'A bed, a table, a desk, three chairs, a looking glass three inches in diameter, a pair of tongs and andirons, a kettle, a skillet and frying-pan, a dipper, a wash-bowl, two knives and forks, three plates, one cup, one spoon, a jug for oil, a jug for molasses, and a japanned lamp.'[6]

We read the shacks' inventories as legends or indices to their political aspirations. The two shacks, one a paranoid extrusion of its puritanical ancestor, communicate via their lamps and their markedly diminutive mirrors. We wish to note also what these shacks exclude: the textile arts have no place in the ur-hut. Windows are never curtained and floors are not carpeted. It is as if fabric would screen or muffle a shack's sincerity. Thoreau explains: 'A lady once offered me a mat, but as I had no room to spare within the house, nor time to spare within or without to shake it, I declined it, preferring to wipe my feet on the sod before my door. It is best to avoid the beginnings of evil.'[7] Was the evil mat hooked or braided or woven? Did it perhaps spell out welcome?

9. The shack fulfills the combined function of cellar and porch, but primarily, like a cellar, it defends an idea of existence: it must house and protect the catalogue of necessity. Crusoe and Thoreau dug their cellars before erecting their roofs. Each shack is also a bunker. In *Discourse on the Origin of Inequality*, written the year Laugier's controversial and popular treatise was published, Rousseau associated the first shack with the birth of social envy and conflict. Where Laugier had aligned the shack with a structural ideal of simplicity and purity, Rousseau conceived it as a defensive barrier against a conflict it also instigated: 'Men, soon ceasing to fall asleep under the first tree, or take shelter in the first cave, hit upon several kinds of hatchets of hard and sharp stones, and employed them to dig the ground, cut down trees, and with the branches build huts ... This was the epoch of a first

revolution, which produced the establishment and distinction of families, and which produced a species of property, and already along with it perhaps a thousand quarrels and battles. As the strongest, however, were the first to make themselves cabins, which they knew they were able to defend, we may conclude that the weak found it much shorter and safer to imitate, than to attempt to dislodge them …'[8] Here primal shack-envy stimulates mimesis, which Rousseau configures as the technical compromise of 'the weak'; architecture inaugurates itself as social rhetoric by framing the family and symbolizing ownership conflicts. This is to imagine sociality in terms of capital and weakness in terms of lack. Certainly the shack can perform this function. But we experience weakness as pliancy, the structural ability to welcome desire and change.

10. Therefore it is not our intention to focus solely on the shack's protective carapace at the expense of its inner ecology of gesture. In Alberti's account of the first shack, in *On the Art of Building in Ten Books*, published in 1450, the original architectural gesture is not the erection of defensible barriers, but the disposition of interior spaces according to their use: 'In the beginning, men sought a place of rest in some region safe from danger; having found a place both suitable and agreeable, they settled down and took possession of the site. Not wishing to have all their household and private affairs conducted in the same place, they set aside one space for sleeping, another for the hearth, and allocated other spaces for different uses.'[9]

Only then did Alberti's first shack dwellers erect their roofs. In the assignment and ordinance of its interior functions, the shack choreographs bodily habit. Recall the film *An American in Paris*. In the artist's studio (one of the city's variations on the self-sufficiency of the pastoral shack), Gene Kelly danced this quotidian gestural economy with the architectural surfaces and furnishings themselves. In the shack, the implied trajectories from bed to stove, from stove to door, from door to larder shelf, animate space with the vivacity of the body. The subject, absent, is nevertheless immanent in the shack's surfaces and in the ordinance of its spaces. In this sense the shack preserves the epistemological structure of classical nature. Absent cause inflects material with a spectrum of functions and interrelations. The voyeur or naturalist identifies herself with causality. The shack is an allegory of origin. We need only study the matter to discern the structure of beginning. By identifying with its disposition, we retroactively become the cause of the shack. We wonder if there exists a body the shack could not imagine.

11. For Vitruvius the shack follows from the sociality of speech. In his shack story, at the beginning of *On Architecture* (27 B.C.), language facilitated men's first social relations. They gathered together around fire and learned to name by imitating one another. The partition and structure of communicative speech and its mimetic transmission was a necessary precursor to architectural structure: 'After thus meeting together they began to make shelters of leaves, some to dig caves under the hills, some

to make of mud and wattles places for shelter, imitating the nests of swallows and their method of building. Then observing the houses of others and adding to their ideas new things from day to day, they produced better kinds of huts.'[10]

We find in Vitruvius a social generosity lacking in the republican myth of the shack: here mimetic building is not the guarded site of security, but a form of engaging speech. In the long series of the Vitruvian shack, mimesis constitutes a creatural social pleasure, a collective communicative agency, contrary to Rousseau's figuration of mimetic art as lack. At the threshold of the Vitruvian shack, architecture's choral function knits the commons.

12. A shack tentatively supplies a syntax for temporal passage. The shack is the pliant site that adds to our ideas new tropes, gestures learned from neighbours, creatures, moot economies, landscape, and the vigour of our own language in recombination. We wish to reimagine the city through the image of the Vitruvian shack. Here citizens inflect shelter with their transient and urgent vernaculars, which include the mimetic lexicons of technology in the service of the *frisson* of insecurity. Here insecurity figures, not as terror, but as erotic collective being. We love shacks because they pose impossible questions. How can we change what we need? How can we fearlessly acknowledge weakness as an animate and constructive content of collectivity? The city is the shack inside out. It choreographs the delicious series of our transience. This is the future.

NOTES

1 Marc-Antoine Laugier, *An Essay on Architecture*, trans. Wolfgang and Anni Herrmann (Los Angeles: Hennessey and Ingalls, Inc., 1977), 11.

2 Henry David Thoreau, *Walden*, ed. Stephen Fender (Oxford and New York: Oxford University Press, 1997), 40.

3 Ibid., 45.

4 Ibid., 27.

5 List of shack contents from author notes on Liz Magor's *Messenger* installation for Vancouver Art Gallery, 2002.

6 Thoreau, *Walden*, 60.

7 Ibid., 61.

8 Jean-Jacques Rousseau, *The Social Contract and Discourse on the Origin of Inequality*, ed. Lester G. Crocker (New York: Washington Square Press, 1967), 216.

9 Leon Battista Alberti, *On the Art of Building in Ten Books*, trans. Joseph Rykwert, Neil Leach, Robert Tavernor (Cambridge, Mass., and London: MIT Press, 1988), 7.

10 Vitruvius, *On Architecture, vol. 1*, ed. and trans. Frank Granger (London: William Heinemann Ltd.; Cambridge, Mass.: Harvard University Press, 1962), 79.

Atget's Interiors

Dossier:
 Photographs by
 Eugene Atget

Fall 2002. *The Office proposed to* Nest *magazine an essay on Eugène Atget's staged photographs of Parisian interiors.*

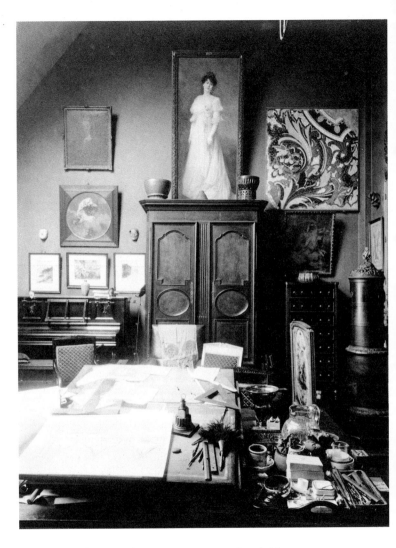

Intérieur de M. C., Décorateur appartements, Rue du Montparnasse

Interior of Mr. C., Decorator of apartments, Rue du Montparnasse

Intérieur de M. C., Décorateur appartements, Rue du Montparnasse
Interior of Mr. C., Decorator of apartments, Rue du Montparnasse

Petite chambre d'une Ouvrière, Rue de Belleville
Small bedroom of a female labourer, Rue de Belleville

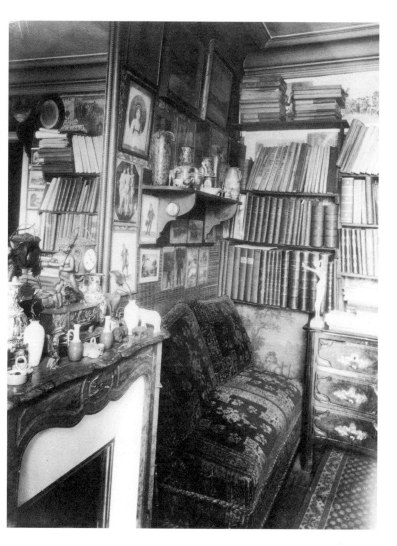

Intérieur de M. B., Collectionneur, Rue de Vaugirard

Interior of Mr. B., Collector, Rue de Vaugirard

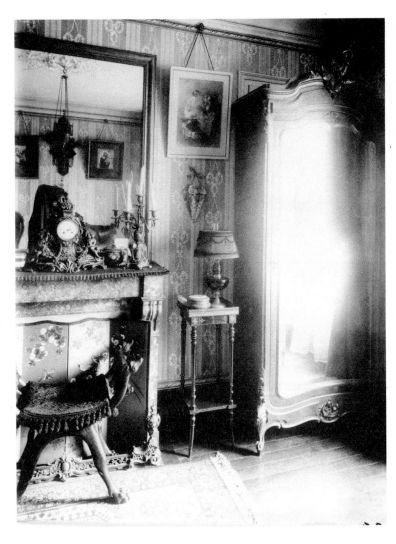

Intérieur de Mme. D., Petite rentière, Boulevard du Port Royal
Interior of Mrs. D., Woman of modest independent means, Boulevard du Port Royal

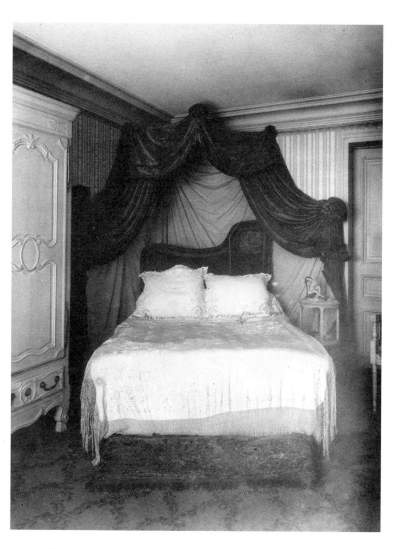

Intérieur de M. F., Agent de change, Rue Montaigne

Interior of Mr. F., Stockbroker, Rue Montaigne

We are furnished by our manners and habits. Yet we can't see what they are. We can't knowingly possess our own ways. They tarry as a cadence in the body; repeatedly we reach to lift the curtain, the dictionary, the cup. This is a measure. Each gesture rhythmically completes itself with its object. We sometimes try to train our behaviors to fashion's apparent timeliness, but thankfully much escapes. Errant regards, approachings, groomings, greetings, compositions and pettings hinge our rhythmic bodies to circumstance: wood, beast, sleep, leather, textile, people. These hinged gleanings cast their material residue in our rooms. A room situates the cadence of habit. Propelled by this meter, we nevertheless glimpse or intuit the contrary shapes of potential browsing at the margins of our study. We pause, then nervously approach, as we might notice then approach an attractive stranger we had felt watching us.

How are we to understand the relation of intuition to habit? They combine on the flat plane of the photograph. Here we can observe their distribution as shadow and light. Our own daily efforts and our rooms mostly fulfill a cadenced anticipation of what living or thinking might be. We would like to study intuition in the photograph, as we might engage in the study of stillness, or curtains, because we want to expand that category's place in our understanding. We would like to gently expand the technique of intuition because it admits change that remains sincere to experience without depending on the past. Intuition reveals the negative space of habit, carving an urgent threshold from the commonplace. Since we would like to become more

surprisingly like ourselves, we cross this threshold. We enter the photograph.

Eugène Atget made these images of Parisian rooms in 1909–10. They were composed as documents for working reference by commercial artists, set decorators for film and stage, painters, architectural restorers and social historians. Working within the parameters of his medium and its market, Atget nevertheless exceeded the economics of intention. These rooms continue to pose questions. We slide our eyes over their surfaces, testing and absorbing. We still search them for information about strangeness we can't yet name. We might recognize the shape of change. This is called research. It intuits absence among the materials.

The photographs offer images of general types rather than authentic situations: The photographer acted as stylist, fashioning the effects of domestic sincerity by altering, re-arranging, decorating, and misattributing the rooms he photographed. He fictionalized some of the addresses and occupants named in his accompanying captions. For example, he labelled his own rooms as those of a dramatic artist, or more reductively as those of a 'male laborer.' The rooms themselves were dramatically composed for the lens in the same way that sets are built. An Empire-style commode installed in the dining room of 'Mr. C.' on Rue du Montparnasse seems to travel to the home of 'Mr. B.' on Rue de Vaugirard. Between shots, Atget removed the glass bell from a mantel clock; each mantel becomes an opportunity for still-life composition. A plenum of bric-a-brac achieves a poignant symmetry. Some stout boots make a reappearance at

a second address. Perhaps that is his own sloppy kitchen standing in for that of a stockbroker. Flowers formalize mantels and tables. These photographs are not diaristic. They present the general boredom and ceremony of domestic economy rather than the private passions of hatred or sex or play. By 'general,' we mean that catalogue of habits invisible to their devotees, habits received through familial, neighbourhood, economic and trade identifications, rather than traits acquired through wilful acts of personality. This ceremonial, and thus general, function of rooms reveals itself in the disposition of furnishing. In bedrooms, coverlets and dressing tables impersonally express shopping, grooming, and housekeeping rituals. Studios show the spatial cliché of the aesthetic. No one has just left these rooms. We search for absent psychopathology in vain. This slightly pagan impersonality continues to invite our look. The gods and the stars themselves are cliché, thus their unearthly attractiveness. The rooms annotate tradition; they also await change.

Atget composed a sequence of sixty photographs numbered and mounted on loose cards or gathered in albums, distributing class typologies across a series: Images of workers' environments and those of the wealthy appear in loose counterpoint. A milliner and an heiress engage in spatial argument. The rooms picture the classes correspondent to the binary identity of French political life at the time. Each class, as Atget composes it, demonstrates a stylistic consistency that adheres across locations. The salon of an important actress, although rococo in reference, shows a concision in choice, a meting out of decorative elements,

a penchant for broad symmetry and a compositional restraint that begins to lean towards modernism's minimum. By contrast, a complex bricolage of disparate objects placed in intimate profusion furnish Atget's own relatively modest lodgings. Gleanings of corporal habit surface the workers' space, complicating the idea of utility – function is texturally elaborated, not formally reduced. Modernist conventions – in which function is reduced to its formal minimum – are at once evident in the décor of the wealthy and absent in the workers' rooms; in this latter place, no gesture is reduced to a single use value, and so thickly accreted layers of errant physicality supercede modernist form. Proletariat furnishing receives and represents in advance the pleatings of potential bodies, so that surface itself seems to act. People's agency has not been abstracted into the transparency of money or authority or function; a stimulating deviance in form interrogates the very concept of function. In moneyed space, the ethos is hygienic. Every housekeeper knows that hygiene is an economy. Will erases surface. Soon the walls will be unnecessary; the plan will open. In Atget's plot, the owning room spends on the transparency of vision, the worker's on haptic desire.

As we browse through the album, the rhythmic effect of the alternating sequence – from one class's sparsely realized design to the other's improvised plenum – is that of a montaged scenario, reminiscent of the novels of Zola, where the rooms themselves are the players. Atget narrates their knotted relations within the frame of the album. He shows the negative space of design, representing with dignity the usually mute

inverse to modernist good taste. The workers' errant accretion is the suppressed ground of modernism; in picturing proletariat space, Atget divulges the economic (and hygienic) dynamic that underwrites the modernist aesthetic. He sold these albums to the archives of the Musée Carnavalet, Bibliothèque Historique de la Ville de Paris, and Bibliothèque Nationale de France for inclusion in the subject files titled 'Moeurs,' a broadly sociological category comprising trade or calling, habits, customs and manners.

Atget's neighbour Gertrude Stein said that paragraphs are emotional, sentences are not. We could extend her distinction: A room is emotional; an object is not. She said 'Paragraphs are emotional not because they express an emotion but because they register or limit emotion.' Habit is emotional; intuition is not. Atget's rooms – as spatial expressions of habit – register or limit emotion as it pertains to social being. This containment parallels the claustrophobia or comforting pleasure of class and other sociological beliefs about identity. Yet when emotion is made visible as form, transformation becomes possible at that form's borders. Atget shows emotion as a matter of internalized sociology. He has furnished the calmness, the smugness, the shame, the vanity and the resignation of these rooms. He has studied the economy of habit and its relation to emotion. He has provided habit with a flat, equal lighting. These documents are not the refuge of dramatic chiaroscuro. Their emotional cadence reflects prewar class structure. Yet by composing a set of comparative limits in the presentation of two aesthetics of class, Atget's images, in the space between, admit the wildness of random

change. They admit the technical ability of intuition to elaborate futures. We look up at our own room to recognize there the sociality of our habits. In the glimmer of recognition resides a transformative pulse. We see that we can change.

We propose that Atget's interiors chart a politics of furnishing. What is to furnish? To supply with the moveable parts of necessity and delight. In a way, furnishing fulfills us by offering frames for our mortality. It describes our attitudes towards time. Patiently it receives and inflects our passage.

This passivity of furnishing is deceptively complex. A table, a chair, and a cupboard each await and receive gesture differently. We are not always able to discern whether our body's customs shape furnishing or if it is furnishing that shapes our bodies, and this blurring of the direction of volition or relation is where intuition locates itself. An item of furniture is a kind of preposition. 'By,' 'with,' and 'of' are material intuitions. Of is a cupboard. With is a table. By is a chair. Each is a kind of household god. It intuits us. Perhaps the worker's furnishing is passivity's plenum. It confounds the boundary between will and reception. The fear of passivity, or gods, teeters right on this boundary. We want to be completely received. We don't want to be fools. How can we know? A room furnishes an unknowability. Much of our composure is dependent on habit's furnishings. But because here we experience an apparently neutral support, our perception can relax and elaborate itself, temporarily free of developmental and functional pieties. It becomes intuition's vital lacework. Intuition ornaments the perception of the present.

Furnishing slowly shows the passivity of the spiritual. It tells us something of devotion and of love: Their volition is reflexive, moves in the multiple directions of ornament. Will and function are not the same: We do not use love or demand its purpose; we enter it variously. Furnishing formally receives us, and this reception is shapely and differentiated even in its allegiance to an absence, which here figures as a replete potential, a promising silence it measures with its walls and tables and windows. So much of love does not yet exist.

Yet by 'furnishing,' we mean something additional to the customary mobilia – bed, shelf, curtain and so on. We mean also the way a room and a person compose an image of time, through a process of mutual accretion, exchange, application, erasure, renovation and decay. By 'furnishing,' we also mean surfaces as they index and influence our wandering transit. Furniture, or composed surface, is transitive. It is structure for touch or approach. Its economy shows reception become form. It figures time as the bending and extension and rest of bodies. This is a room. It archives touch. Like an archive, its passivity seduces and structures us. It asks us to enter in its other language. Every room is romantic.

We say that we furnish. But the forms of furnishing are the forms of really ancient love, the love of shy gods and passing things that pause for us, facing an elaborate elsewhere. At the threshold of the room and the photograph, we are that elsewhere.

SOURCES

Agamben, Giorgio. *Means Without End: Notes on Politics.* Trans. Vincenzo Binetti and Cesare Casarino. Minneapolis: University of Minnesota Press, 2000.

Cache, Bernard. *Earth Moves: The Furnishing of Territories.* Cambridge, Mass.: MIT Press, 2000.

Chesterton, G. K. *On Lying in Bed and Other Essays.* Calgary: Bayeux Arts, 2000.

Nesbit, Molly. *Atget's Seven Albums.* New Haven and London: Yale University Press, 1994.

Proust, Marcel. *On Reading Ruskin.* New Haven and London: Yale University Press, 1987.

Stein, Gertrude. *Lectures in America.* New York: Random House, 1935.

The Value Village Lyric

Dossier:

Photographs by
the Office for Soft Architecture

Spring 2003. A version of this essay was written for the catalogue Baja to Vancouver, *to accompany the West Coast group show of the same name. Research was conducted at the Victoria Drive Value Village in East Vancouver, and in interviews with Sydney Hermant and Sarah Edmonds at the Or Gallery (Vancouver).*

Society, which the more I think of it astonishes me the more, is founded upon cloth.

– Thomas Carlyle

We cannot fix our object. We are anxious and bored and must shop. With this scribbled grooming we thatch ourselves anew.

We want an impure image that contradicts fixity. Something deliciously insecure: the sheath of a nerve. We go to the House of V to encounter the glimmering selvage of the popular. We handle retrospect labels and fibres. We analyze cut. We study change. We believe that the tactile limits of garments mark out potential actions. We excavate a strange jacket from the anonymity of mass memory and slip our arms into the future. In this way we constitute the dandiacal body. The garment italicizes the body, turns it into speech. At the house of V we attend festal, vernacular vanity:

'What's your shirt?'

House of Vitruvius, House of Venus, La Dolce Vita, House of Varda, House of Werther, House of Venturi, House of Vionnet, House of van Brugh, the Velvets, the Viletones, Versailles, Visconti, House of Vorticism, Vivienne Westwood, House of Verlaine, House of Van Noten, House of Vygotsky, House of Vico, House of Vishnu, House of Velasquez, House of Voysey, House of Vreeland, House of Viva, Luxe, Calme et Volupté, House of Wordsworth, House of Versace, the Blessed V, House of Valentino, House of Verdi, Violette Leduc:

We are the Market. We are the House. Garishly we turn to face you.

This is the revolutionary costume. This is the volup-tuous eclipse of affect. Our address is superfluous. Then, there is the fluency of crêpe de chine, of fine batiste, of crumpled linen, of Dacron, Orlon, and defunct polyesters, of Lamex and Lurex, pvc and good wool twist … The fibrous layers build out and mould our soul. This textile thatching is our practice. This facing is our fabulous task. What garment is adequate? Did we dream that the red pigment from the cloth binding of Carlyle's *Sartor Resartus* had stained our nightreading fingers? Even our pronoun is tailored. A French seam sculpts it. Ergo, clothing is meta-physical. It constitutes the dialectical seam threading conscious-ness through perception. Like metaphysics it wears out. We prefer ours secondhand.

At the House of V, modernity greets the rag trade. Here, theo-ries are cheap. Cast-off Being dangles from the racks. Under the harsh, flat light of fluorescent tubing, all labels and movements converge in a convenient and accessible archive. This is the mirror image of the avant-garde: like an unraveling shawl, it recedes from its economy. We finger the bad judgements in mass-market branding; we fraternize with frayed and gaudy trousers as if we remembered them; we mimic the seaminess of markets. We choose among lurid failures.

It's nice to find something locally made. A Granville Street couturière. Remember the label? Paris-styled. Certain purchases are mythic. Schiapparelli's red scribble on the back of the silk tie.

A scarred Marrimekko tote. Junk from the Gap. Homemade things unfinished. Unknowable labels. The shirts of teams. Has it shrunk? You could cut off the sleeves. Asymmetrical sequined stuff. The Comme des Garçons skirt. How do you wear it? '70s Dior. A dirndle from his peasant period. It would never fit. It's a kind of arcade: A catalogue of the garbage, the degradation, what doesn't work, what's bad or unrecognized. Thrashed things. Macramé. Loiterers. Departmentalized shame. The daydream of Baudelaire's jacket, all ripped and frayed.

This is also the school of luck. When faced with the aleatory, we need parameters; we need a house. When we want to research the relation of randomness to the erotic, we stroll here of an afternoon. We glimpse lady Fortuna slip into a torn fur coat. At the House of V all houses clandes-tinely meet. The mixed-up day becomes luxurious. We want to use the word 'cosmos.' Strange, necessary answers un-spool into visible, tactile life. They'll have this mustard yellow pull-out extremely heavy leather couch. Not leatherette.

The House of V is a combinatory paradise ruled by pathos and grotesquerie. We think it feels gratuitously sexual: each garment describes differently the collapse of the ideal. In long, wide aisles ideal for contemplative promen-ade, red-smocked workers rank shabby disjecta by gender, age, ethnicity, reproductive status, size, colour, object and garment type. It's overlaid by a maudlin pop soundtrack mixed with inspirational aphorism. We hum along. Here, eroticism is liberated from gravitas. All difference is equivalently accessible because it has been rejected – by fashion,

boredom, death, and time. We only need Luck. Like curious gentlemen botanists, brethren in the dialect of our discipline, we drift through a bounded yet open system of kinds.

Value Village occupies the window-walled shells of abandoned Modern supermarkets, off peri-urban low rent strip malls. The first store opened in San Francisco in 1951. The chain spread northwards up the Pacific coast, into Canada, then, by the 1990s, eastwards, much like a kind of errant plant. Its formula includes parking lots. Its signage is banal and its hours are liberal. Shoppers are anyone, such as architects and queens. Most work as solitaries; some as pairs. Underpaid scarlet clinicians of abjection are ready to assist. We enter with the undirected potential of boredom. The House of V addresses desire, not taste. Here boredom is useful. There is too much surface. All intention is pointless and must be abandoned. Selection takes directions within the system without aiming at ends. It begins with passivity. We submit to louche textiles. We feel disgust, timidity, and glee. It proceeds by dissociation and division. We observe the simultaneous prolifer-ation and cancellation of origins. We adapt to a random texture, and this adaptation becomes a material movement. We try it for fit. The fibre is stimulating. We're wearing a metaphor, lightly emanating a stranger's scent. It's like a drug. It's departmentalized. It produces exper-ience synthetically. We define desire thus.

They buy the clothing in big bricks, bound together. They buy it from charity. Unconscious data. There is always more. Mauve nylons. Car-coats. Rick-rack. These garments are lyric struc-tures cast aside. Motley existence has passed through them.

Now they are profit. Their vulnerability lends us a rhetoric. Wandering in this beautiful wilderness of restraint and no innocence, our gaze is relaxed and technical. We're not afraid of cliché. In the worn-out, anonymous garment, material sentiment has been liberated from cause. Here sentiment extends enjoyably into the indeterminacy of detritus. Anything is possible. We'll conduct our life unrecognizably. Recombinant figures of memory present themselves. We'll untwirl that life. Sociology becomes ornament, like a decorative scarwork. The seam has been caringly mended. From random documents of uncertain provenance, unstable value, and unraveling morphology, we produce new time.

We think of the casual bravado of Baudelaire's tied black cravat against the scrim of white collar in the photograph by Nadar. The fabric of his coat is stiff, with shiny folds at the torso. The shoulders have an unfamiliar, mincing cut. The upper collar is velvet. Where his hand rests in trouser pocket the jacket flips back to show the dark silk facing. We wish we could experience the fit of this jacket, slip our arms into the ruched sleeves of Baudelaire. Its odd skimpiness would translate our stance. Its worn cuff would brush our books, absorb our ink. We would realize the place of the pronoun beneath the binding torso of the tail-ored jacket, which would give our soul troublesome, deluxe shape. We would be handsome and sparkling.

At the House of V we luxuriate in the unoriginality of our desires and identities. They are clearly catalogued. They unravel back to a foundational boredom. The proliferation of failures

resides for a moment on that frayed surface. In the tedium of failure we glimpse the new. It is neither a style nor a content, but a stance. There is no place but a stance. It accepts all that is defunct, such as Europe and America. It drifts and plays and enunciates and returns, unheroic.

SOURCES

Benjamin, Walter. *Illuminations: Essays and Reflections.* Ed. Hannah Arendt. New York: Schoken Books, 1969.

Carlyle, Thomas. *Sartor Resartus: The Life and Opinions of Herr Teufelsdrockh.* Boston: Houghton Mifflin Company, 1924.

Levinas, Emmanuel. *On Escape.* Trans. Bettina Bergo. Stanford: Stanford University Press, 2003.

Seven Walks

First Walk

(Once again the plaque on the wall had been smashed. We attempted to recall the subject of official commemoration, but whatever we said about it, we said about ourselves. This way the day would proceed with its humiliating diligence, towards the stiffening silver of cold evening, when the dissolute hours had gathered into a recalcitrant knot and we could no longer stroll in the fantasy that our waistcoats were embroidered with roses, when we would feel the sensation of unaccountability like a phantom limb. But it is unhelpful to read a day backwards.)

My guide raised the styrofoam coffee cup as if it were the most translucent of foliate porcelains. During the instant of that gesture morning was all recollection, vestige – something quite ordinary to be treated with love and intelligence. From our seat on the still, petal-choked street we reconjured the old light now slithering afresh across metropolitan rooms we had in our past inhabited: rooms shrill and deep and blush and intermediate, where we had felt compelled to utter the grail-like and subordinated word 'rougepot' because we had read of these objects in the last century's bawdish books; rooms with no middle ground, differently foxed as certain aging mirrors are foxed; shaded rooms pleasure chose; shabby, faded rooms in which, even for a single day, our paradoxical excitements had found uses and upholsteries; rooms of imbrication and elaboration where we began to resist the logic of our identity, in order to feel free.

And specifically we recalled the small pinkish room above the raucous market street, the room whose greenish sconces had seemed to transmit new conditions for an entire week. This was the room where, in first light, a rhythm was generating some sort of Greek Paris, the room where, still-too-organic, we discovered we could exude our fumbling as a redundant architecture.

My guide deliberately swirled the final sugars into the steaming fluid in the cup. 'The fragile matinal law makes room for all manners of theatre and identity and description of works, the tasting and having, bagatelles, loose-vowelled dialects – lest we get none in paradise.' We rose from the wooden bench. We felt limber and sleek and ambitious: Ready. We agreed to prepare the document of morning.

When we built our first library it was morning and we were modern, and the bombed windows admitted morning, which flowed in shafts and tongued over stone. Paper documents had been looted or confiscated; new descriptions became necessary. Twelve pixilated scenes from the life of a teenager replaced walls. The pigments were those of crushed weeds under skin and just for a moment we left our satchels leaning on the font.

The satchels, the pixilation, the confiscations: What actually happened was a deep split, deep in the texture of mortality. We had been advised in the morning papers that there was no longer a paradise. Hell also was outmoded. That is why we were modern. We built this library with an applied effort of our memory and its arches were the chic curvature of our tawdry bead necklaces turned up on end. We laced its hollowness with

catwalks, to make use of our intellectual frivolity. We could survive on these catwalks, slung across the transept, the emptied stacks, the nave, the richly carved choir, dangling our little bright plastic buckets for earthly supplies, and the bombed windows served as passages for our smoke. Always we were waking suspended in this cold library, as our neighbours were waking on their own narrow scaffolds and platforms, performing their slow, ornamental copulations, and we called our matinal greetings like larks.

It was a preposterous reverie, borrowing several of its aspects from stolen engravings we had seen and coveted and surreptitiously slit from expensive books in order to furnish the numerous inner pockets of our coats. But we felt some sort of use had to be made of the abolished heaven. Since it was redundant, now we could colonize it. Ours was a *fin-de-siècle* hopefulness, which bloomed in tandem with its decay.

The resting point of our long avenue was the shipyard with its jaunty assemblage of stacked containers. We talked of the bare co-mixture of stuff and life in the stacked hulls of freighters, strangers shipped anonymously in containers among their dying and dead. We had read of this also in the papers, how in the city's ports the wracked individuals had been prised or extruded as mute cargo, living or dead. They had attempted to migrate into experiment. The rhetorics of judgement and hope are incommensurate. We spoke of these rhetorics because morning is overwhelmingly the experiment of belief. We rise into the failed library of *civitas*. We agreed for the moment not to speak of the

nature of the individual tether, the institutes and lordships and instituted shortages, and certainly this agreement marked our complicity with the administration of shortage. But we did not know any other way to go on. We in no sense expect to be excused from judgement because, our own ancestral arrivals having receded into the billboards and whitewash of public myth, we cannot fully imagine the terribly anulled waking of strangers buried in the lurching hulls of ships. We wished also to include in the document our wilful ignorance and forgetting, not to ennoble them but because they exist in a crippling equiva-lence with the more doctrinal sentiments, such as pride and shame.

There we were, nudging the plentiful chimera of the fore-ground, maudlin and picturesque in our rosy waistcoats and our matinal etiquettes – please? – of course – if only – my pleas-ure – dawdling into the abstract streets. Or let us say that we were the scribbled creatures who received the morning's pronouns and applied them quixotically to our persons. Perhaps morning simply helped us to feel somewhat pertinent.

Clangour of the rising grates of shops, rattles of keys, the gathering movements in the clearer warming air, rhythmic drawl of trucks of stuff, skinny boys in aprons dragging bins of fruits, shut markets now unpleating themselves so that the fragile spaciousness leafed out into commodities. And this played out to the familiar accompaniment of the sub-melodic birds of our region, striving away in the boulevard trees. Yet we could in no way say that the hour was a development towards a phantom differentiation: already it contained everything, even those

elaborately balanced sentences that would not reveal themselves until noon, even the long passivities, even the lilac suckers at night plunging up. We consulted the morning as a handbook of exempla as outmoded as it was convivial.

And what did we acquire through the consultation? Was it dignity or the final limpid understanding of a fashion in love? Or was it a hint of that suave heaven made from Europe (slightly mannish, famous for violets and roses, extra-refined and commodious with stuff)? Obviously we were confectioners. At least we were not hacking with random anger at the shrubbery and the absences, dulling our instruments. Yet we envied that capacity for anger we witnessed in others. Our own passions often prematurely matriculated into irony or doubt, or most pathetically, into mere scorn. We consulted morning also because we wanted to know all the dialects of sparkling impatience, bloated and purple audacity, long, irreducible grief, even the dialects of civic hatred that percolated among the offices and assemblies and dispatches. We wanted knowledge.

We entered this turbulence in our document as a blotted, perky line, a sleazy glut and visual crackle in gelatinous, ridged and shiny blacks, an indolent pocket where self and not-self met the superb puberty of a concept. We understood latency, the marrow. We watched girls with briefcases enter the architecture, the ones we had seen juggling fire in the alleys at night. Morning is always strategic.

Inextricably my guide and I were moving towards lunch, our favourite meal.

Second Walk

Habitually we walked in the park late afternoons. Slowly the park revealed to us the newness deep within banality. This was the city where the site oozed through its historical carapace to become a paradoxical ornament. In this way the emblem of the park could appear anywhere on our daily routes, insinuating itself deviously within the hairline cracks in capital as we ourselves were apt to do. Amidst persistently creeping foliage we would tease out wiry angers and saccharine tenderness mixed, in this manner both flaunting and secreting our souls. In any case we were radically inseparable from the context we disturbed. It was as if everything we encountered had become some sort of nineteenth century, this long century that encroached so splendidly on much of July. We would lean on its transparent balustrade, rhythmically adjusting our muted apparel, waiting somewhat randomly to achieve the warmth of an idea. But you should not assume that my guide and I were entirely idle. Waiting was many-roomed and structured and moody, and we measured, then catalogued, each of its mobile affects. We dawdled morosely in the corners of waiting, resenting our own randomness. Or we garnered our inherent insouciance towards the more subtle sediments of passivity. But it is hard to make remarkable faults in a spiritual diorama. Only slowly did contrary dreamings appear. Only slowly did we come to see our own strolling as a layered emergency: we recognized that we were the outmoded remainders of a class that produced its own mirage so

expertly that its temporal disappearance went unnoticed. We found ourselves repeatedly original. The diva, the waves, the hotel, aroma of apples – these were structures in us. How like lyric we had been. Here, then, was the warmth, here the awaited idea. We were equally maligned and arrogant, performing our tired doggeries against a sky inlaid with phrases. We were of the lyric class.

Ours had been a rarified training – haute décor of dragonfly on cirrus, the crickets shriller. Our favourite objects were spoons. The eroticization of a privileged passivity twisted, turned, passed and remained. Inexplicably both prim and sensuous, we drifted then and gamboled in puffs of golden dust. We were meant to be starlets. But since that time our grooming had undergone much revision. This rigged our vernacular also in a sort of lapsed trousseau. We now called our garments shifts or shells or even slacks. As the lyric class indeed we pertained to all that was lapsed or enjambed. Even our pathologies were those of a previous century, as when beside the daily marital protocols, lovefights wake a neighbourhood. Remember lovefights? Nor could we act and change deliberately: although we desired fine clothes and freedoms on the patio of late modernism, what our passivity achieved or attracted were the fallen categories of experience – the gorgeous grammars of restraint, pure fucking and secrecy and sickness, mixtures of unclassifiable actions performed in tawdry décors, passional sincerities and their accompanying dialectics of concealment and candour, cruelty and malice, the long, ill-recalled choreographies of greeting

and thanking, memory. Our agonies were farcically transparent and public. Yet those fallen categories, seemingly suspended in some slimy lyric harness, came to animate and rescue our bodies' role as witness, witness to the teaching and fading cognitions of the park.

Here, on the clipped margins of the century, in our regalia of mud-freckled linens, and with our satchel of cold provisions, we needed to prove to ourselves at least that although we had no doubt as to our lyric or suspended status, we were eager to be happy. We wanted to be the charmed recipients of massive energies. Why not? Our naïveté was both shapeless and necessary. We resembled a botched alfresco sketch. Who could say that we were a symmetry; who could say that we were not?

Previously I mentioned the spiritual diorama. Just for the satisfaction, I'll repeat myself. 'It is hard to make great and remarkable faults in a spiritual diorama.' We knew our happiness was dependent on such faults – proportional errors, say, which expanded the point where the passional and the social meet, or the misapplied tests for chemical residues, which revealed only the critical extravagance of our narcissism. Yet our attraction was inexplicably towards the diorama. The glittering attires and airs of summer began to vitrify so that we felt ourselves on the inside of a sultry glass, gazing outwards towards an agency that required us no more than we required the studied redundancy of our own vocabulary. Hope became a spectacle, a decoration. Anger was simply annulled. All that we could experience inside the diorama was the fateful listlessness usually attributed to the

inmates of decaying houses, or to the intolerable justice of better-
ment, the listlessness of scripted consumption. It was innocuous
and pleasant, but it did not move.

Thus, the park. The bursts of early evening rain would thrust
the foliage aside and shape a little room for us, promising truant
privacies. Fragments of a hundred utopian fantasies of one sort
or another mingled with all the flicking and dripping. My guide
would utter gorgeous nonsense simply to intrigue and tickle
me, such as 'Swinburne couldn't swim' or 'Seeing is so inexperi-
enced.' Is it possible to persuade towards disassembly? For such
a persuasion is what the park performed upon us, loosely, luxu-
riantly, but not without malice. If the park were a pharmaceuti-
cal, it would be extruded from the stick of an herb called
mercury; if it were a silk, its drapery would show all slit-film and
filament printed with foam. If it were a velvet (one of those worn
ones that shrinks or adheres like a woman's voice with ruptured
warp and covert intelligence); if it were a canvas (all ground and
flayed beyond the necessity for permanence). We were meant to
inquire 'whose desire is it?' and we did inquire, of the lank damp-
ness, the boulder tasting faintly of warm sugar, of the built
surfaces also, such as benches and curbs – we inquired but we
were without the competence to interpret the crumbling
response. And the tattered cloud and leaf tatters transferred to us
sensations that we did not deserve. In the park, our generous
government had provided conditions for the wildest fantasy – but
what we repeatedly released ourselves into were the rehearsed
spontaneities of poverty fables, the erotic promise of acts of

disproportion and spatial discomfort, dramas of abandonment, the commodious weaving and bleaching of screen-like stories, as if we were to one another not amorous colleagues but weird sockets of uncertain depth.

'Our happiness' 'our naïveté' 'our attraction' 'our regalia' 'our humiliation' 'our intention' 'our grooming': this is the habitual formula I have used. While normally such a grammar would indicate a quality belonging to us, in this landscape the affects took on an independence. It was we who belonged to them. They hovered above the surfaces, disguised as clouds or mists, awaiting the porousness of a passing ego. By aethereal fornications they entered us. We had observed the images and geometries of such intercourses in the great galleries, print rooms and libraries of our travels, but here we ourselves became their medium. And as in those galleries, the affects that usurped or devised us were not all contemporary. The park's real function was archival. Dandering here, a vast melancholy would alight upon us, gently, so as not to frighten, and the pigmented nuance of a renaissance shadow eased its inks and agitations beneath our skin. Or we were seized by a desperate frivolity, plucked up, cherub-style, into marooned pastels and gildings. We foxed the silver mirrors up there and absorbed the nineteen meanings of the flexure of the human wrist. Or a fume would swathe us in the long modern monochrome of regret. I insist that we did not choose to submit to these alienations and languors. It was they who chose us. 'No space ever vanishes utterly,' said my guide.

If I have mistakenly given the impression that my guide and I were alone in this vast parkland, it is because our fractured emotional syntax rendered us solipsists. In fact the park was populated by gazes. They swagged the sites where desire and convention met. Now we found an advantageous perch on a marble curb near the plashing of a minor fountain. We unfastened our satchel; we intended to nibble and observe and refract. We ate two champagne peaches. A gamine laced in disciplined Amazonian glitter strode past. Her trigonometric gaze persuaded us entirely. Clearly she was not mortal. We chose a fig and discussed how we approved of arborists – here the specifically Marxian arborist emerged from among branchwork like an errant connotation. With our pearly pocket knife we cut into an unctuous cheese and again the clouds tightened and the lilies curled and the little child ran cringing from us to its mother. We ate the cheese. 'Hey, cobweb,' a soldier called out, and the light fluxed in patterns of expansion and contraction. Oh, and the long leonine gathering from the green eyes of the womanly boy, his essence feathering, his gestures swelling, his fabrics purely theoretical. No interpretation could extinguish this. When we methodically compared him to what we already knew of boyhood – the strange dialect, the half-finished sentences, the exorbitant yearning for certitude – we experienced the delirious bafflement of a double pleasure, a furious defiance of plausibility. But the plausible would never be our medium. And then the ranks of slender bachelors frantically propelling themselves in too-crisp suits towards the chemical alleviation of loneliness, so

frantically that they could not glance, could not comprehend the invitation of the glance, so that to them we were naught. And then the merely dutiful glance of the courier, which halfheartedly urged us towards a bogus simplification, and then the she-theorist sauntering purposefully from her round hips, her heavy leather satchel swinging like an oiled clock. Her saturate gaze demanded secret diplomacy, public contrition and intellectual disguise, so that we blushed and were flung among swirling canals, sleaze, simulated musculatures, collective apertures, gaudy symbols, kits of beautiful moves and paper parts, vertiginous scribbles and futurist hopes. The she-theorist knew something more crimson than place. We felt suddenly and simultaneously that we should hire a theorist to underwrite our fantasies, the thought communicating by the mutually nervous adjustments of our carefully tousled coifs. She passed and we became tenants of a dry season, professionless. Her hazel gaze had informed us that we merely frolicked in semblance. Our pencil spilled across the silent path. A black panting dog loped past. And so on.

The gaze is a machine that can invent belief and can destroy what is tender. In this way it is like an animal or a season or a politics, or like the dark bosco of the park. Our scopic researches aligned us, we liked to think, with the great tradition of the natural philosophers, for whom seeing was indeed and irrevocably inexperienced, and wherein the admission of such inexperience served as an emblem or badge of belonging. What can we claim about the park, about the sorrows that are and were not our own?

Nothing. We simply sign ourselves against silence. But the gaze and our researches upon it might yield a medium for a passional historiography, building with their interpenetrations a lattice-work for civic thought. We remembered the free women moving from city to city eating fruits in their seasons previously. To be those women, their feminine syllables bristling, to be a modernist declining the spurious hybridizations and pollutions that we intermittently adore and repudiate, to cup a superb expectancy in a sentence, to make with our hands a sensation that is pleasant and place in it then a redundant politics: this is not quite it. But as researchers we were bound to scrupulously visit each potential explanation for the scopic piety we so cherished. Admittedly it was a relief when we found the explanation lacking. For to continue with our researches was our strongest wish. The inevitability of failure became our most dependable incentive. And as we strolled through the park to accomplish our speculations always we wondered – were we inside or outside the diorama?

Third Walk

I said to my guide: 'Must we recede into the wild spending of intelligence? Might we go to dinner and have a fight upon a little sofa?' My guide said yes. Although we agreed to assume that each thing that we witnessed was real, I do think I first imagined what we later knew.

Evening. Palindromic façade: recalibrated symmetries. The temperature swings. Torqued pillars; quoted porch. Quibbles say nothing about the life-sized streets, the life-sized society, the justice of human warmth as you enter evening. The rain looks expensive beneath sodium lights. Or perhaps it's the word 'justice' that has an expensive sheen. We went to restaurants.

We pass through a sheer façade. We find ourselves efficiently courted, seated, appeased. Bleached textiles quiver. Placating foods appear. In this setting, even the pale monochrome corners would further prompt my guide's peculiar formality. How would one recant an atmosphere? As a ruthlessly bland texture crosses my palate I lightly slap my guide's impassive face. Gastronomy restores nothing; neither would the wet street beyond the translucent glass. There, words want tamping. From the strained sauces, the melting, the fillets of tender pigeon, the conical arrangement of cherries, the aspics and the little grill of twigs, the giblets and vinaigrettes and pale and quartered hearts and the sieved and the thick and firm and moderate, the emptied pods, the shallow dishes with their slippery rims, the routinely macerating heart – I abruptly rise and, clattering, flee into the

aforementioned street. We had had asinine hopes. We preserved them in brines according to the precise instructions of ancient didactic books. The words I wanted tended to become wasted infatuations, and here I will recall little of the troubled interpretation of mutability, gifts of cheerful money or sullen money, the wedding of skin-like textures, the fastidious rinsing. It was not merely the diminished typologies nor the deferred substitution of semantic monotony for touch. It was something ubiquitous and squandered and ultra-minimalist about which, finally, I could say nothing. So I walked, beyond the bare lobbies downtown and further. There was no window in the city that was not overtly moralistic – the roadways were illuminated and my decadence seemed to soak the asphalt so it shone. Ah, the longing for feeling, the tiny jaws of feeling.

Next, a syntactically cylindrical eating arena that converts spectacle into innovative light. We shall not enter this establishment: we do not care for the lucrative sugaring of glutinous cakes. Or, theatron (also a sort of eating arena flaunting contrapuntal gastronomic sighs). This is a high-status vacuousness, a superb adroitness, an actual veil of redundant brilliance. What else would we expect from the public quotation of a market's dream? Each vast room displays sociological moments as if the physical texture of watching inspired a décor. The flavours are plagiaries. The beverages ripple in heavy cups. In each sip a second, and occasionally a third sensation can be perceived. Though my guide and I had agreed, in principle, that taste can be doubled, or indeed multiplied, I grow to loathe the sumptuous,

the elegant, the draped volumes, smooth pleasure's well-known hand. In this plenum, my boredom is an embarrassment so I cease to speak. From the brackish echo of public sensation my guide's neutral face absorbs a cruel and varnished sneer. Our silence is a style of temporary hatred, nourished by each little loosened oyster we swallow, each acidic little kiss, each sweet-meat, each odour of saturation, each quirky, saline broth. This cuisine reduces ennui to an essence, or worse, a glaze. The blurred arrival of exquisite courses is a sentence. We pluck at posh linen.

Or, engaged in close, indeterminate conversation which causes the mingling of the plundered textiles of our sweeping coats, we open an anonymous door, cross a rough threshold, and descend directly to the commercial heart of pleasure and regret. A diminished idea of daylight suffuses the soft membranes of the lower world. Poignant gasps; translucent rosy porcelains: the cradle of all that. Someone must believe in the chiaroscuro of love and aluminum. A mannered curve that has become a complex-ity meanders into radiating slits. Before this neon-lit rhythm of niches, these glimpses into figured inaccessibility, we do not understand whether we are guests or clientele. We can't ever request the rare fishes poached in foreign creams, nor the substantiation of the perfume of cumin, and other, intangible herbs. It is the restaurant called shame. Our mouths can't speak words. Although we are slavishly willing to imitate them, we comprehend none of the gestures of the articulate diners. We observe the inhalation of dirty powders from the small hollows

on the backs of the diners' upheld hands, the flick of throats and the subsequent cluttering of laundered shirts. We cannot discern whether we have entered a microcosm or a landscape or a lackadaisical simulation of time. Pleasure is a figured vacuum that does not recognize us as persons. We stand annulled in our ancient, ostentatious coats.

This is how my guide and I passed our evenings. To sup became a refinement of irreparable insinuation, but also a realignment of specifically anodyne architectures with the complicit banalities of our soul. Yes, we were banal. We would call for 'a little dish of honey,' 'a dish of theory,' as if they could slake the burn of phenomena. What else was there to do? Bray up to love's ceiling? Deliberately polish the lovely, whoring dust? Practice the anticipation of failure? We never left doubt out of our studies. We were a purpleness learning itself. And if we spoke in the accent of the rhetorical past, in the myriad ligatures of cities, if desperation belonged to our texture, it is because, massively vulnerable, we were precisely unfree. We embodied the conflation of elegance and shame. Or did I only imagine that I had read reports of strange experiments in hunger and wandering before I set out to represent them with my guide and my body and the buildings and their intensities and their foods and the streets? We had agreed to assume that each thing that we witnessed was free. Was that the fiction of the strangeness of the city?

In the script that we followed, every cry was preserved by a dream. We constructed a journey out of a series of games of chance. Governments and volleys established themselves in our

method. We found examples of the most brilliant hopes encumbered by verbal ambiguity, and from this ambiguity we composed elegant terms of expression. But the happiest days of our life are incomprehensible deliria, frontiers whose passages are blocked by words. We had recourse to material and rightly or wrongly we assigned the word rapture to its strangeness and obscurity. We knew memory to be superfluous ornament. And yet all our thinking is memory. Our investigations will terminate in a sublime falsehood; we will have failed to draw a waking life. We can't hold the stiff blood of paradise over silent paper.

Fourth Walk

The sky over the defunct light-industrial district was still the sky, less sublime, but more articulate. And walking what we witnessed was, like a flickering appetite, the real end of sunlight, buildings torn out of the earth and forgotten, the superabundant likenesses of pictured products collapsed into our dream and over and over in the dark the flickering appetite now bunched under the ribs. We were partly in another place. It's hard not to disappear. I pondered this ritual of crisis and form as my guide and I walked the unprofitable time of the city, the pools of slowness, the lost parts. We breached the city's principal at every moment with our incommensurate yearnings, and in the quasi-randomness of our route.

Ruined factories rising into fog; their lapsed symmetries nearly gothic. The abandoned undulations of the vast mercantile storage facilities, the avenues of these – sooty, Roman, blunt – and down below, the clapboard family houses with little triangular porticoes, lesser temples in the scheme, but as degraded. And in these rough and farcical mirrors, the struggle to recognize a city. By a habitual process of transubstantiation, some of this struggle was named 'the heart.' But we wanted the heart to mean something other than this interminable roman metronome of failed eros and placation, something more like the surging modifications of the inventive sky. So we attempted to notice the economies that could not appear in money: vast aluminum light sliding over the sea-like lake; the stacks of disposable

portable buildings labelled Women and Men; decayed orchards gone oblique between parking lots and the complex grainy scent that pervaded the street. As we walked we presented one another with looted images, tying them with great delicacy to our mortal memories and hopes. It was as if at that hour we became strands of attention that spoke. In this way we tethered our separate mortalities to a single mutable surface. This was description, or love. 'We must live as if this illusion is our freedom,' said my guide.

Freed, we moved into the anxious pause pressing forward, that pause shown to us in its detailed itinerancy by every failing surface, every bland or lurid image, each incapable caress. The world was leaning on us, leaning and budding and scraping, as if it too was subjected to strange rules never made explicit.

Fifth Walk

My guide and I carefully selected our item, which I then purchased using my father's money. I still remember clearly our journey back from that indiscrete neighbourhood: the lattice of little streets brindled with soft rain; the cheerful and nonchalant passing of messengers who we imagined were accompanying or parsing our gentle excitement; the way the late shadows made bowers for our tentative embraces, there among the sooty shops peddling used cups and hairpieces, and the hawkers and their fractured syntax, and the smell of spoiled fruit lingering in the moist air like an outmoded style of punctuation. Each matched, quickening step we took was a fresh conceit for the fibrous intimacy this new item promised to ambassador – or rather it was old content, even, though I may seem indelicate, used, since the tiny, poorly lit shop where we had chosen it, a shop whose shabbiness was strangely distinguished by the murmur of cultish erudition and disdain among its cloaked habitués, offered many slightly differing items, some enigmatic as to the techniques of their application, others of an obtuseness that titillated our inexperience while seeming to promise only minimal subtleties, but all united in their concupiscence and great antiquity. Each freshened the enigma of ancient dignity. We had chosen only after having appealed to the somewhat intimidating expertise of the shopkeeper, who had with hushed authority advised us to consider methodically both the unique and the importantly banal qualities of each item until a latent texture

compelled itself towards our skin. Now, on the strewn pavements, our urgency increased in proportion to the luxurious withdrawal of light from the greased sky. We ignored the crowds that we resembled. This was a journey of hurried, determined steps, of distant irregularities, of involuting grammars, of tumescence and slurried rain. I tightened my clasp on the scarlet packet that seemed so generously to absorb the pulse of my anticipation. I believed that soon my cherished guide and I would become dependents of experience. We hardly limped at all.

The weather smeared a ripe grey evenly over the lengths of our bodies. My guide and I talked about cold things to punctuate our adjacency. Sometimes our sentences began to cancel our flesh, their stately clefts of emotion erasing our bounded proprieties. And yet the hard structures of our palates were palpitating something tender and immaculate. And I must refer also to our phonemes, which in the soft air seemed to gloss earth with its sullen particles. Our woolen sleeves mingled their shining raised sheaths; my heart was suspended in the icy sky, sifting and rationing gesture. Early evening had pulled after it an imprecise dusk. All of this gave us more time.

Our desultory conversation veiled the inadvertent transgression of our route into the Secular District. The courts of my father's sanctuaries trickled their viscous light into the scoured streets. Huge columns flanked us. A tersely bent figure passed with tight-hipped gait, purposefully diminishing into the hostile iteration of a colonnade. We exposed ourselves to grimly imagined dangers in navigating this district. Our foreboding

protected our bodies with hot surges of attentiveness. We scanned the shadowed gateways and clinging porches; we realized we would be known by our steps if they were heard by savants. Our ambered fragrance also distinguished us, and the woolen coats that brushed our ankles were of a flexible cut little appreciated by the tenured acolytes. I slipped our purchase into my deep inner pocket. The subtle pressure of its weight against my torso transferred to me a sensation of quietude – I felt both inviolate and assuaged.

Beyond the porticoed towers the broad street rose to address a sort of quincunx or grove. Generations of wanderers had remapped the city's inchoate routes to lead to this district's venerated mound. My guide and I, like many other travellers, were pleased to briefly enjoy the hospice of that thick-set wood. For we were not alone among the pedestaled trees that named the myths of liberty. We knew our sylvan companions among pommier d'Antoinette, Fiennesque elm, Nosier de Certeau, by the same means we had feared would precipitate our own recognition. Garments of rare subtlety and variety spoke the generous courage of their wearers – soft seams modelled mobile torsos, drape of ineluctable cloths framed the specificity of gait, fanning collars shielded the tenuous vulnerability of throats. As we penetrated the semi-lit margin of foliage to join this covert gathering, we saw, half-concealed in cedar and mist, a gold cab waiting. Through smoked glass the leaning driver covertly signalled to us. We entered the insuperable femininity of neglect. We receded into upholstered anonymity.

I would prefer to narrate an indiscernible movement towards a pronoun caked in doubt, but the gentle rocking of the car, the mock-innocence of gesture, the closed-in heat, suggested certainty. I did not know that those surfaces would lock. In that life, in that narrative, a shared object shaped our moral cusp. I thought of my guide, who was like a text that coverts itself through the most inexplicable activities – erased reflexes, ineptitude, insensitive deposits – as if the dispersed will could simply become something. Under the faintly saffron skin, beneath the curved black hairs that seemed engraved in their exactitude, under that loose skin with slight texture visible as a screen, a history of shifting proportions hid itself in the brackish pleasure of its own autonomy. It was as if my guide had extra conceptual organs washed up into the body like flotsam. This history was giving my guide life from a slightly altered or fragmented perspective, which affected me also – perhaps magnetically, or by some other sympathetic or electrical means. I sensed it internally. We were listing on stained velvet on the back seat of the cab. Our loose comfort metered the pocked road, the sudden turns and pauses. Blurred neighbourhoods slid past the glass: indulged white sculpture, burnt odour coming forward, glass grid, fringes of dust, errant monument, lit inscription and condensed ornament, darkened market, republican lustre of oil on canal water, threshold, embassy, paper, mast. I thought of my guide's stolid happiness, a happiness that circulated as a substance or a vapour might, sometimes to linger at the churlish skin, at other times to rush through the limbs as a mobility of

means, and sometimes to pool around the gilded organs, remotivating the ancient tenure of introspection. My guide's was a practised thought which administrated unknowable generosities of detail with felicity. Yet this complexity was sparingly deployed. Observing my guide had taught me that happiness is the consolidation of complicities.

Undoubtedly I am misunderstood. Although I am not unaware of the fraught uses of the belling word 'complicity,' the company of my guide had pleated, among its maligned syllables, intimations of the byzantine bonds fastening want to its soft cage. That 'we' in its moot atmosphere, clinking against knowledge, was circumfluent to the propriety of doubt. If we were abstract, if we cupped ambiguity and translucence, we also gave to one another the spurious syntax of thought. Books swell and shirts flower: events please by deferring bounds. But these words are vagaries that cannot indicate the wanton suppleness with which we attached ourselves to the tensing flesh. We were held to our wandering by permissive texts that also reconciled our itinerant lusts: our simplest membranes applied themselves to the world only under their querulous agreement. I know that when I say 'the world' I resort to a tired method of reference. Each pronoun I used was a willing link in a chain of nonchalant extravagance that locked us to both luxury and thought. Hopefulness bent into its own opacity. Even the terse display of grief concealed reflexive superfluities. (I speak here of the civic grief that has passed from sorrow to anger, as such grief does during the extremes of ethical abandonment.) As love requires a politics, so worldliness cathects.

Then, in the humming silence of the cab, a movement of that inexorable body closer to mine. My guide said, 'There are distances so detailed you feel compelled to construct belief. But it's the same finite drama of utterance. Something is not being represented. One day you will laugh at even this substitute, this obedience, this hope.'

Kids in their nylon halos of beauty were passing. We saw the street lamps annotate their grace. Loose certainties of gait forestalled astonishment. Our car, still for a moment, occupied the centre of all their luminosity. I was witness to my own desire, as if erased, and it was something like history: a frivolously maintained dependency on the cancelled chimeras of place, the obscene luxury of an analysis that rejects what it next configures as reversed. Nevertheless I wanted.

Sixth Walk

I feel I can look through the paintings and narrations, the sentences and devices of knowledge, the pleasure and melancholy, through the strange windows with their yellow light and shadows and curtains in the style of someone else's childhood. I can begin to see through another's technique of forgiveness or introspection.

When I started off towards my guide the bridge seemed to be made of astonishingly tawdry materials. Branches, twine, tiny mirrors, smashed crockery, wire, bundled grasses, living fronds, pelt-like strips, discarded kitchen chairs of wood their rungs missing, sagging ladders, bits of threadbare carpet, cheap shiny grating, rusted metal strips, gilded frames of nothing, lengths of fraying sisal rope, straw mats unravelling, limp silken roses on green plastic stems, tattered basketry, twisted papers, flapping plastic tarps lit from beneath, woven umbrella spokes, stray asphalt shingles, stained toile de Jouy curtains their wooden rings rattling, a ticking cot-mattress bleeding straw, swollen books stuffing the chinks of the swaying sounding structure, everything knit as if with an indiscernible but precisely ornate intention which would never reveal the complexity of its method to the walker. This was not a bridge I would have chosen to cross. I awoke already embarqued on the superb structure. There was nothing to do but continue. What the bridge passed over changed as I walked. At first, rivers of motor traffic hissing on a black highway, this with the skewed strangeness of a foreign

highway, sulfur headlamps occasionally emblazoning the trembling bridge, which by then had become a cradle of slung planks, their wrist-wide gaps admitting blue-black silence of a forest, punctuated with the snapping and crashing of branches and odd whistlings in the wind, which rocked me also.

I believe that solitude is chaos. I believe that the bridge came to be swathed in undulating stuff, unknowable fibres that fluctuated like the dendrites of nerves, in response to the minute flickering of thought and light and things astral as well. My fingers stroked its pure oscillation. There was a sensation of cushioning, of safety, which at the same time was not different from chaos – as if unknowable varieties of experience would be held gently, suspended in an elastic breeze. What this experience was I can't say – it was held by the bridge the way sleep is contained by the person. Solitude and sleep are autonomous and festal. Gorgeous structures cradle them. We can approach the structures but not the substance, which is really more like a moving current. Then the rippling of fibres converted themselves again to foliage, as all speech converts itself to foliage in the night, and I felt this rippling simultaneously all over my skin. It was not necessary to differentiate the sensations of particular organs or leaves since this rippling unknit the proprieties and zones of affect – the entire body became an instrument played by weather and chance. We are so honoured to live with chance.

I wished for my guide to join me on this bridge. I dawdled and sauntered and loitered at its sultry interstices. In expectation I adjusted my maudlin garments and touched my hair. Everything

around me unbuttoned. Did I cause this? Perhaps it was dawn, or something lucid. Animals were crossing. Mules and dogs and cattle. Children too. Bicycles with devilish horns. The bridge-urchins were at their card games and games of dice. Some of us were men and some were women. Some of us cheated. And in this matter also it was not necessary to differentiate. Some wore secular velvets and I touched them in passing, then uttered the velvet syllables. We carried wrapped packets. Some scattered papers. Some would sing. Maybe one was my guide. I called out not knowing if my voice would arrive. The harsh or worried sound simply blended with the frequency of motion. Was it a name? What could I hear or follow? The bridge was gently swaying; I wished to receive and to know my guide. But stronger and newer and more ancient than that wish was the barely recognizable desire to submit to the precocity and insecurity of the bridge itself.

Imagine a very beautiful photograph whose emulsion is lifting and peeling from the paper. There is no longer a negative. To preserve it you must absorb this artifact through your skin, as if it were an antique cosmetic comprised of colloidal silver. You must absorb its insecurity. Imagine the post-festal table, rinds and crusts and pink crustacean shells and crumpled stuff smeared with fats and juices, the guests gone, for a moment the raw morning utterly silent, your shirt stained with the wine, your face pulsing with the specific sadness of something you won't know. Imagine a sound with no context. Only that emotion. It is not called doubt.

Context has become internal, rather than hovering as a theatrical outside. Like new cells speak us. We call itself a name. We call it change and beautifully it's swaying as the new electrical patterns fringe our sight. Everything is tingling. We forget about Europe. It won't hurt soon. Soon we will relax. We will walk above polders and marshes and roads. The clouds are real or painted.

Seventh Walk

We had been at our physical exercises. Now we entered into the late civic afternoon. The scissoring meters of the apparatus had left us lucid, distant, and extreme. Cool air parsed our acuity. Although we indeed sauntered in the street, through the grey discourse called human and concatenations of rain (in short, in the mode of the ordinary), my guide and I perceived as from a vast temporal distance an impertinently muttering tide of ambitions and ticks. It was our city. We recognized the frayed connective cables sketched by words like 'went' and 'pass,' the sacral nostalgias fuelling violence and the desiring apparatus of love. Utopia was what punctuated the hum of disparities. Utopia: a searing, futuristic retinal trope that oddly offered an intelligibility to the present. We saw that we could lift it and use it like a lens. We observed guys in their cities, guys in their cities and their deaths and their little deaths and mostly what we coveted was their sartorial reserve, so marvellously useful for our purpose. 'The fact remains that we are foreigners on the inside,' opined my guide; 'but there is no outside.' And it was true that inside any 'now' there was the syllable-by-syllable invention and the necessity for the disappearance of faces and names. Therefore we wanted only to document the present. For example, women – what were they? Arrows or luncheons, a defenestration, a burning frame, the great stiff coat with its glossy folds, limbs, inner Spains … Our hands forgot nothing. We searched for these pure positions to frame with our lens. Our foreignness was a precisely burdensome gift.

Make no mistake. Here I am narrating an abstraction. When I say 'our lens' I do not intend to indicate that, like the master Atget, we hauled a cumbersome and fragile equipment across neighbourhoods. I do not refer to an atelier made opaque by the detritus of use, the economy of repeated gestures trapped in the mended furnishings, vials of golden dusts, privacies of method, sheets of albumen. Nothing was known about that. And when I say 'women' I mean nothing like an arcane suppleness or a forged memory of plenty. I'm painting the place in the polis of the sour heat and the pulse beneath our coats, the specific entry of our exhalations and words into the atmosphere. And when we pass each reflective surface, glimpsing our passage among sibylline products, what are we then if not smeared stars, close to it, close to what happens; the sequin, the syllable, the severance.

This is a manner of speaking; never fear hyperbole. In practise we knew intimately the inadequacy of means for discerning the intelligible. Given inevitable excess, irreversible loss and unreserved expenditure, how were we to choose and lift the components of intelligibility from among the mute and patient junk? We wished to produce new disciplines within the lexicon of the secular; we paid a ferocious piety to artifice. In a way we were just rehearsing.

We began to imagine that we were several, even many. In the guise of several we lounged dissolute on nonce-coloured couches, bold in conscious merit. What we were to ourselves: fabulously dangerous. We never performed the pirouette of privation. Dangerously we pulled our kneesocks up over our

knees. We asked the first question and we answered. What is earth? – A haunt. A tuft. A garland. An empress. A mockery. Girlfriend. A violet. A milk. A cream. A hazardous trinket. A flask. A basket. A mimic. A wild ideal pageant in the middle of London. A plinth. A liking. A bachelor. A thickening. A military straggling. And the severance, utter. And so on.

As many or several we played other games as well. We would mottle our vernacular with an affected modesty because we enjoyed the noble sensation of bursting. Flippantly we would issue implausible manifestoes, seeking no less than to abolish the therapeutic seance of novelty. When there was a call for images we would fan through the neighbourhood constructing our documents. Our method was patience. We would slowly absorb each image until we were what we had deliberately chosen to become. Of course then we ourselves were the documents; we acquired a fragility. Hello my Delicate we would repeat when we met by chance in the streets under the rows of posters Hello my Delicate.

And we learned that as many we could more easily be solitary. As solitaries, this is what we would do. We would silently practise the duplicitous emotion known as anarchy or scorn. We would closely observe strangers to study how, in a manner, or in a touch, we might invent the dream of the congress of strange shapes. We would make use of their resistance; it showed us our own content. We were not at all pleasant. As I said, our intentions were documentary.

One of us was famished for colour; this one would lasciviously brush up on the paused automobiles as if it were somehow possible to carnally blot the knowledges locked in those saturate and subtly witty pigments. One of us would take eight days to write a letter describing the superb greyhound of the Marchesa Casati, as painted by Boldini; the sublime haunches of the slightly cowering creature, and the intelligence of its ears. One of us wanted only to repeat certain words: diamond, tree, vegetable. This was the one who would touch the street with the point of her toe to establish its irreality and this is the one who would scream through the filters of gauze to illustrate the concept 'violet' and this is the one who remembered flight. This one remembered flight. This one remembered the smooth cylinders glimpsed at evening through the opened portals of the factory. What discipline is secular? This one remembered each acquaintance by an appetite. This one remembered each lie, each blemish, each soft little tear in the worn cottons of the shirts.

But now we needed to abandon our pastime. My guide and I found ourselves leaning into the transition to night. Everything had a blueness, or to be more precise, every object and surface invented its corresponding blueness. And the trees of the park became mystical, and we permitted ourselves to use this shabby word because we were slightly fatigued from our exercises and our amusements and because against the deepening sky we watched the blue-green green-gold golden black-gold silver-green green-white iron-green scarlet-tipped foliage turn black.

No birds now; just the soft motors stroking the night. Stillness. We went to our tree. It was time for the study of the paradox called lust. Our chests burst hugely upwards to alight in the branches, instrumental and lovely, normal and new. It was time for the lyric fallen back into teeming branches or against the solid trunk gasping

Acknowledgements

Each of these essays is an experiment in collaboration with the forms and concerns of my community. That this community, as varied as it is, has shown such a consistent generosity of spirit towards the Office for Soft Architecture places me very much in its debt – to formally thank each individual here is insufficient and probably impossible, but necessary.

Susan Edelstein of Artspeak Gallery inaugurated the Office's practice by commissioning 'Soft Architecture: A Manifesto' to accompany an exhibition by Sharyn Yuen and Josée Bernard. Later *Nest* magazine invited Petra Blaisse's participation for the Manifesto's republication. Various editors at *Mix* magazine in Toronto, including Peter Hudson, Jennifer Rudder, Kyo Mclear, and Sisi Penalosa initiated early projects. I researched fountains at Allyson Clay's invitation; the report was later published in *The Stranger* (Seattle). Hadley Howes and Maxwell Stephens contributed a portfolio of the phantom fountains of Vancouver. Lytle Shaw requested a contribution to *Cabinet*'s 'Horticulture' issue; Renée Van Halm and Reid Sheir occasioned an exploration of colour for Renée's show *Dream Home* at the Contemporary Art Gallery. At very abbreviated deadline, Renee designed a graphic version of her colour project specifically for this book. Again at Artspeak Gallery, now under Lorna Brown's directorship, I worked with sculptor Elspeth Pratt and designer Judith Steedman on a catalogue for Pratt's show *Doubt*. Grant Arnold of the Vancouver Art Gallery worked with me on two projects:

'Arts and Crafts in Burnaby,' for a special issue of *Collapse*, and the essay on shacks, for the catalogue accompanying a retrospective of the artist Liz Magor. His sensitive eye helped my scholarship. Liz generously contributed the shack photographs from her archive, as well as good table company and a beautiful mohair sweater. Roy Miki, of Simon Fraser University, invited me to present the Office's work at the conference 'FutureNearPresent-Tense,' sponsored by *West Coast Line* magazine. Daina Agaitis of the Vancouver Art Gallery asked me to write for the catalogue for the group show *Baja* to Vancouver; the 'Value Village Lyric' resulted, but not without the assistance of V.V. aficionados Sydney Hermant and Sarah Edmonds, who allowed me to interview them. *Nest* magazine again invited a contribution, this time on the interiors of Atget; my thanks to Joseph Holtzman, Paul Franklin, and not least to Matthew Stadler, my editor at *Nest* and also at Clear Cut Press. The fidelity and warmth of Matthew's attention as an editor and a friend inspires and teaches me, and has significantly improved these texts. My deep thanks to him and to all of these people and institutions.

The essays also reflect Vancouver's changing urban texture during a period of its development roughly bracketed by the sale of the Expo '86 site by the provincial government, and the 2003 acquisition by the province of the 2010 Winter Olympics. In this period of accelerated growth and increasingly globalizing economies, much of what I loved about this city seemed to be disappearing. I thought I should document the physical transitions I was witnessing in my daily life, and in this way question

my own nostalgia for the minor, the local, the ruinous; for decay. It was efficient to become an architect, since the city's economic and aesthetic discourses were increasingly framed in architectural vocabularies. In writing I wanted to make alternative spaces and contexts for the visual culture of this city, sites that could also provide a vigorously idiosyncratic history of surfaces as they fluctuate.

It became possible for me to write the walks, which appear in the second part of the book, when I received a grant from the British Columbia Arts Council in 2000. Some were published by Andreas Kahre, of the Western Front's *Front* magazine, by Miriam Nichols in *West Coast Line*, by Linda Marie Walker, in the Australia-based online journal *Parallel*, by Matthew Stadler, in a guest-edited issue of *Arcade: Journal for Architecture and Design in the Northwest*, and by Susan Clark, of *Giantess*. My thanks as well to these editors and their publications.

OSA has also benefited profoundly from the conversation of friends in many cities. Through Vancouver, Toronto, Montreal, Seattle, London, Paris, Astoria, New York and San Francisco, I have felt gratitude for the good company of my fellow walkers: Erin O'Brien, Erin Moure, Lorna Brown, Margot Butler, Stacy Doris, Chet Weiner, Keith Donovan, Matthew Stadler, Keith Higgins, Kathy Slade, Lissa Wolsak, Eileen Myles, Gerry Shikatani, Lynn McClory, Bob Glück, Jerry Garcia, Rich Jensen, Laynie Browne, Dodie Bellamy, Steve McCaffery and Lytle Shaw each helped. So did many others. Participants in my workshop 'of Walking' at the Kootenay School of Writing in Vancouver

shared their perspectives and researches on various Vancouver neighbourhoods. Robin Mitchell, of Picnic Design Group, took on a complex project with good grace and humour. I'm particularly fortunate that Stacy Doris agreed to read the manuscript and compile for it an index; this document reflects the wit and sensitivity of spirit that has inspired me as a reader of her poetry and as her friend.

About the Author

Born in Toronto, Lisa Robertson lived in Vancouver for twenty-three and a half years.

Her books include:
The Apothecary
XEclogue
Debbie: An Epic
The Weather
*Occasional Work and Seven Walks from the Office for
 Soft Architecture*
Rousseau's Boat
The Men
Lisa Robertson's Magenta Soul Whip
R's Boat

Credits

Photographs not otherwise cited in the text are reproduced with permission from the following sources:

pp. 6–11: © Andreas Pauly. Photos of Petra Blaisse's curtains for the Mick Jagger Centre, Dartford Grammar School for Boys, Kent, England. Courtesy *Nest* magazine, no. 11 (winter 2000–2001).

p. 84: 'G. E. Clayton, strawberry farm, Burnaby.' Courtesy British Columbia Archives, c-05777.

p. 156: B. C. Electric Railway photo. Courtesy City of Vancouver Archives, lgn 824.

p. 157 (left): Jack Lindsay photo. Courtesy City of Vancouver Archives, cva 1184-1928.

p. 157 (right): Jack Lindsay photo. Courtesy City of Vancouver Archives, cva 1184-2926.

p. 158: Untitled. City of Vancouver Archives, sgn 40.

p. 173: Photos of *Messenger*, an installation by Liz Magor. Courtesy Vancouver Art Gallery.

Inside cover: B. C. Electric Railway photo. Courtesy City of Vancouver Archives, lgn 824.

Index

by Stacy Doris

Typeset in Albertina and Akzidenz Grotesk
Printed and bound at the Coach House on bpNichol Lane

This edition designed by Alana Wilcox
The Clear Cut edition was designed by Tae Won Yu, with production and
 layout by Robin Mitchell
The original edition was copyedited by Viola Funk and Allison Dubinsky
The pompom on the cover and essay title pages is by Kathy Slade,
 courtesy of the artist

Coach House Books
80 bpNichol Lane
Toronto ON M5S 3J4

416 979 2217
800 367 6360

mail@chbooks.com
www.chbooks.com